KYUUTO!
JAPANESE CRAFTS:
FUZZY FELTED FRIENDS

by Saori

CHRONICLE BOOKS
SAN FRANCISCO

First published in the United States in 2008 by
Chronicle Books LLC.

First published in Japan as *Felt no Chiisana Doubutsu Motif
Zakka* in 2006 by Kawade Shobo Shinsha Publishers.

Copyright © 2006 Saori Yamazaki.

English translation rights arranged with Kawade Shobo
Shinsha Publishers, Tokyo, through Rico Komanoya,
ricorico, Tokyo.

Library of Congress Cataloging-in-Publication Data available.

ISBN: 978-0-8118-6066-6

Manufactured in China

Text: Saori Yamazaki and Korin Tsuda
Photography: Satoru Abe
Styling: Yukiko Hoshi
Illustration: Junko Raiko
Book design: Eiko Nishida (cooltiger), Andrew Pothecary
(forbidden colour), Yukie Kamauchi, Kumiko Ota (GRID)
English copyediting: Alma Reyes-Umemoto (ricorico),
Seishi Maruyama
Production assistant: Aki Ueda (ricorico)
Chief editor and production: Rico Komanoya (ricorico)

10 9 8 7 6 5 4 3 2 1

Chronicle Books LLC
680 Second Street
San Francisco, California 94107

www.chroniclebooks.com

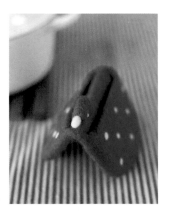

Contents

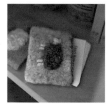

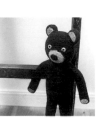

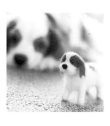

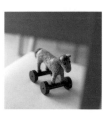

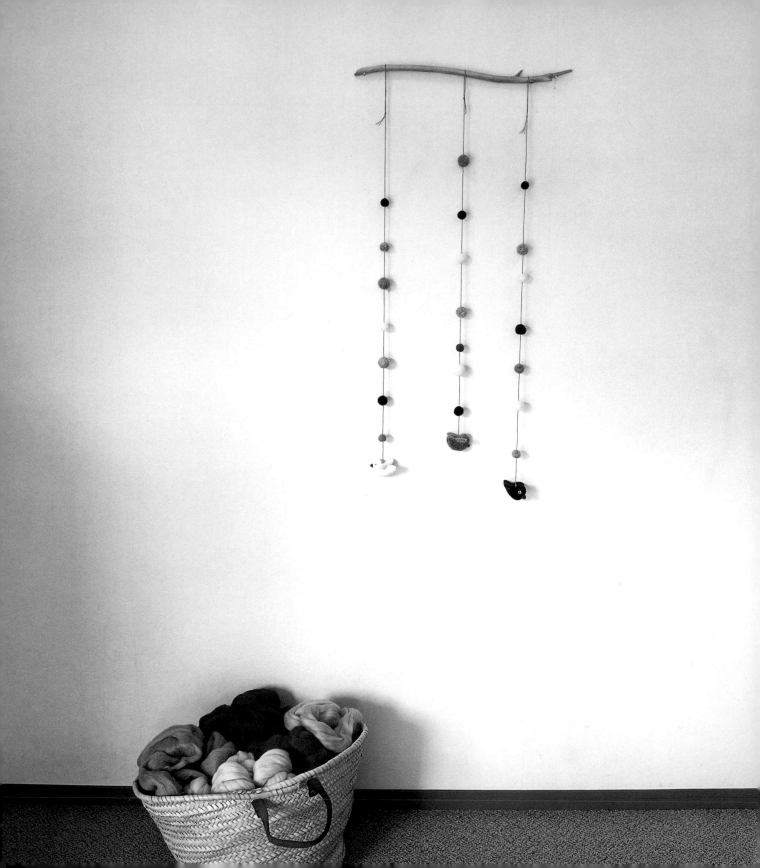

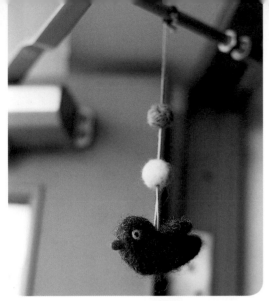

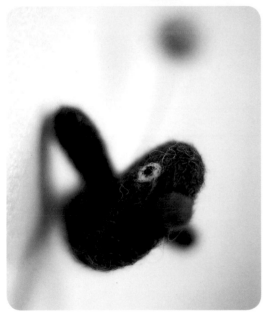

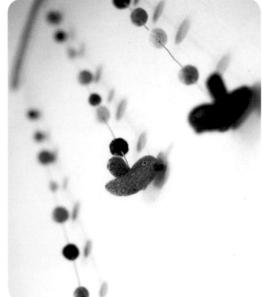

● Small Bird Ornament

These light birds and felt balls are easy to make and can be arranged to suit your room decor by adjusting the length of the string.

See pages 48 and 58 for pattern instructions.

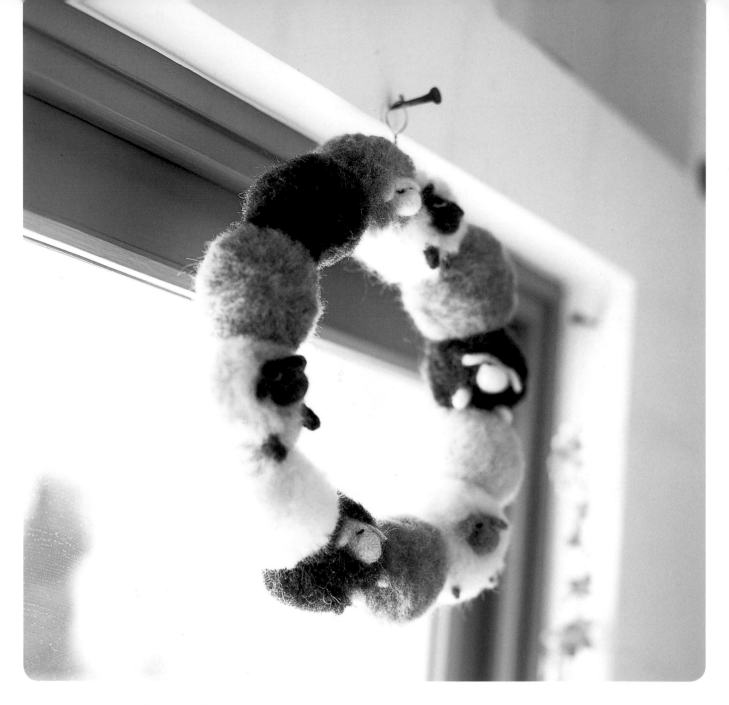

● Sleepy Sheep Wreath

A sleepy sheep wreath gives a peaceful atmosphere to your room. It can easily be made with simple needle work—especially the face and hooves.

See page 58 for pattern instructions.

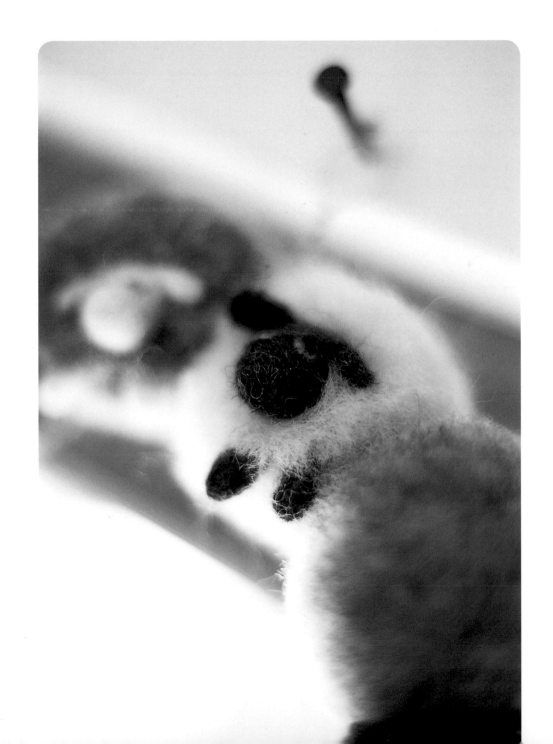

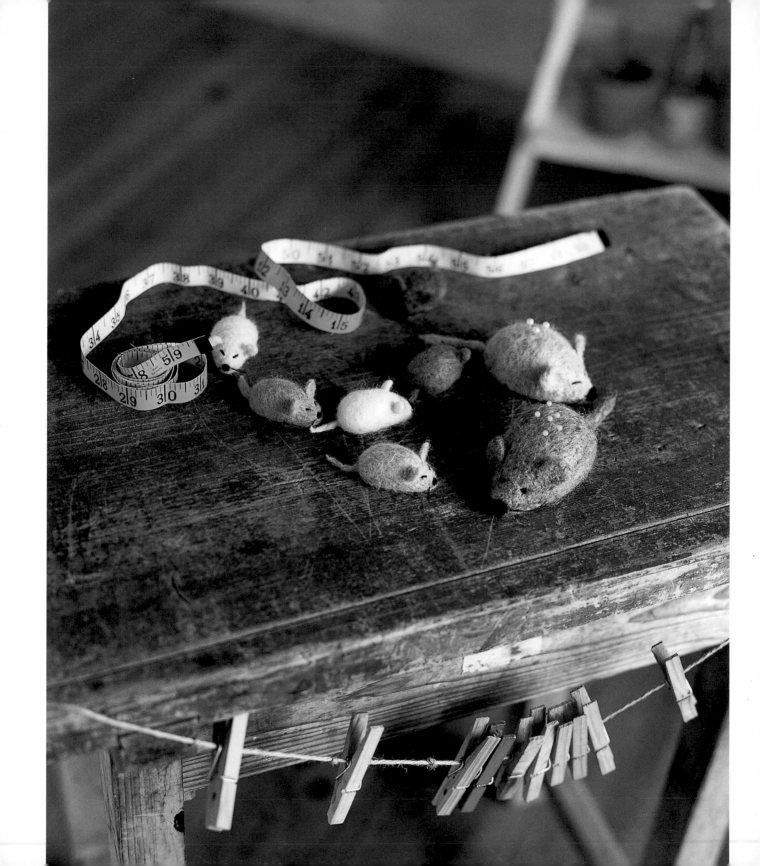

My sewing box memory.

A sewing box reminds me of my great-grandmother.
She made kimonos, bags, dolls, small beanbags, and
everything else that you can think of. I recall clearly her
fingers, sewing one beautiful stitch to another very carefully.

She taught me the joy of handicraft, and I will always
fondly remember the time I spent with her.

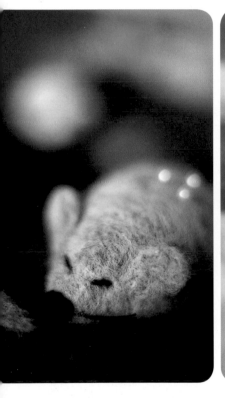

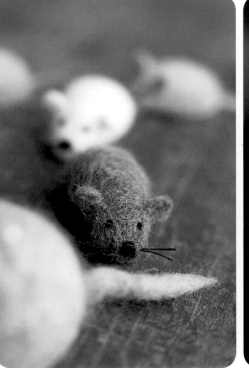

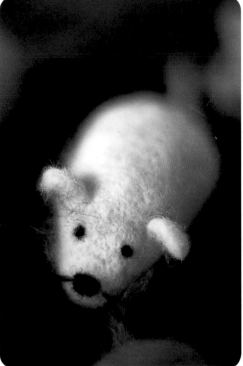

● Mouse Pincushions

Chubby mice make enjoyable handicraft.
Wool prevents the needles from getting
rusty due to its natural oils.

See page 59 for
pattern instructions.

9

● Pink Gecko Magnet

This naughty gecko stamps his feet while climbing up the refrigerator. He holds onto a photograph through the magnet attached to his stomach.

See page 59 for pattern instructions.

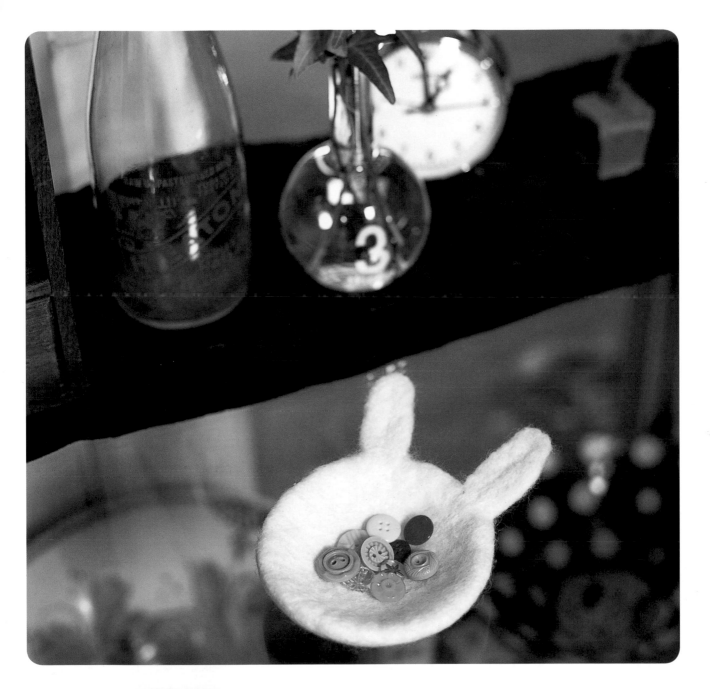

● Rabbit-Shaped Plate

Make a round bottom base for a plate.
If you finish it with a deep base, it becomes
handy for your valuable jewelry or treasures.

*See page 60 for
pattern instructions.*

● Bird Pouch

This bird pouch gives one a heartwarming feeling. Felt work does not require treatment of the edges; thus, you can easily attach a zipper.

See page 60 for pattern instructions.

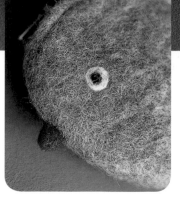

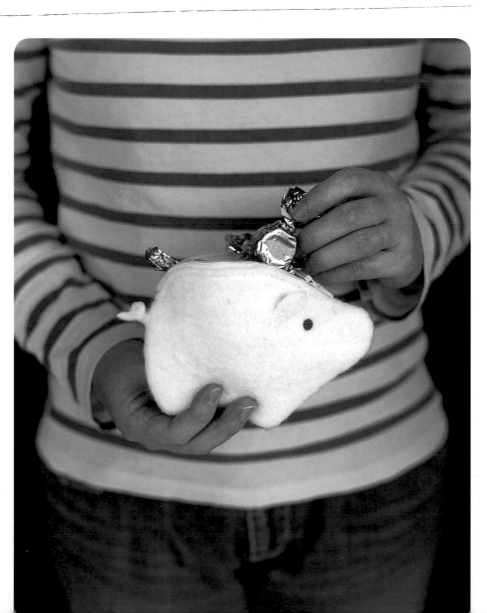

● Piglet Pouch

You can take this white piglet everywhere. Its turned-up nose and small, curly tail are its most charming features.

See page 61 for
pattern instructions.

● Giraffe Bag for Taking a Stroll

This small and simple bag is useful to carry
when visiting your neighbors. Attach a yellow
giraffe on it for accent.

See page 62 for
pattern instructions.

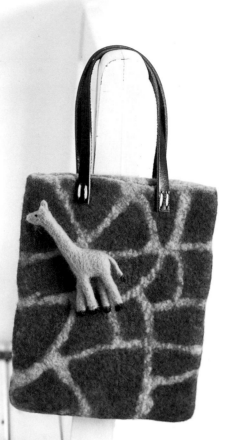

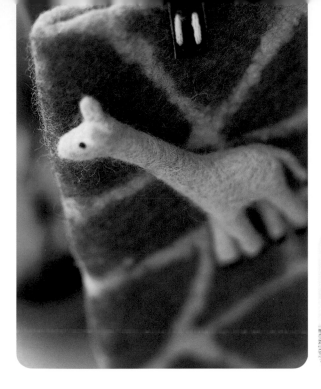

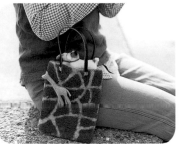

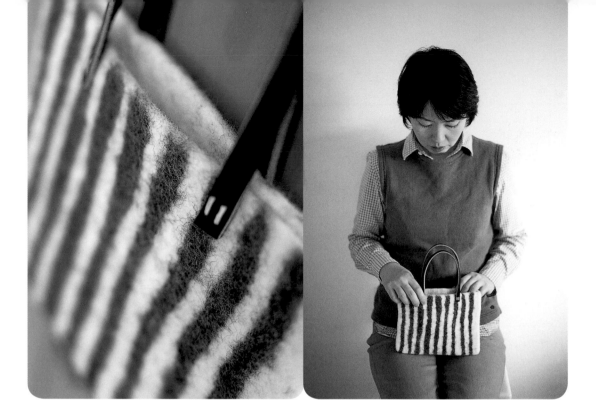

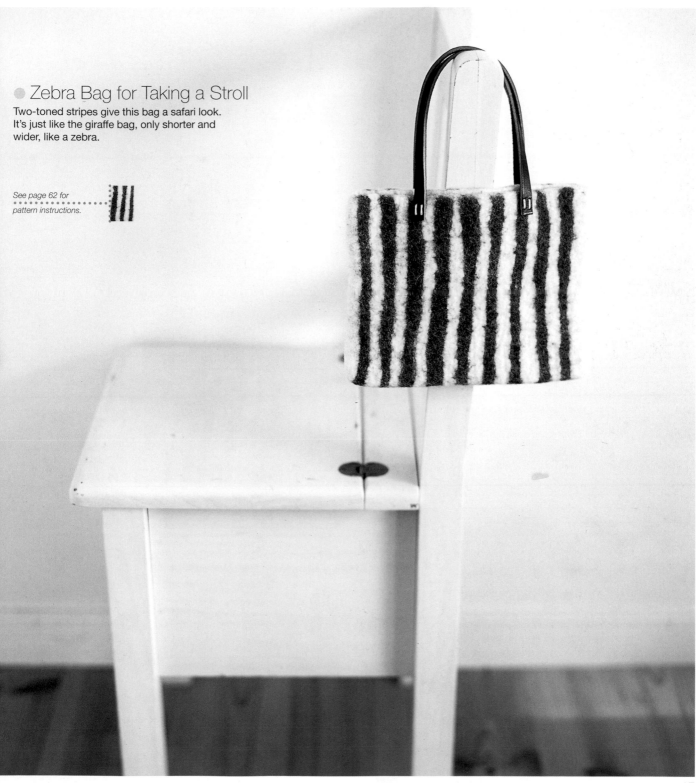

● Zebra Bag for Taking a Stroll

Two-toned stripes give this bag a safari look.
It's just like the giraffe bag, only shorter and
wider, like a zebra.

See page 62 for
pattern instructions.

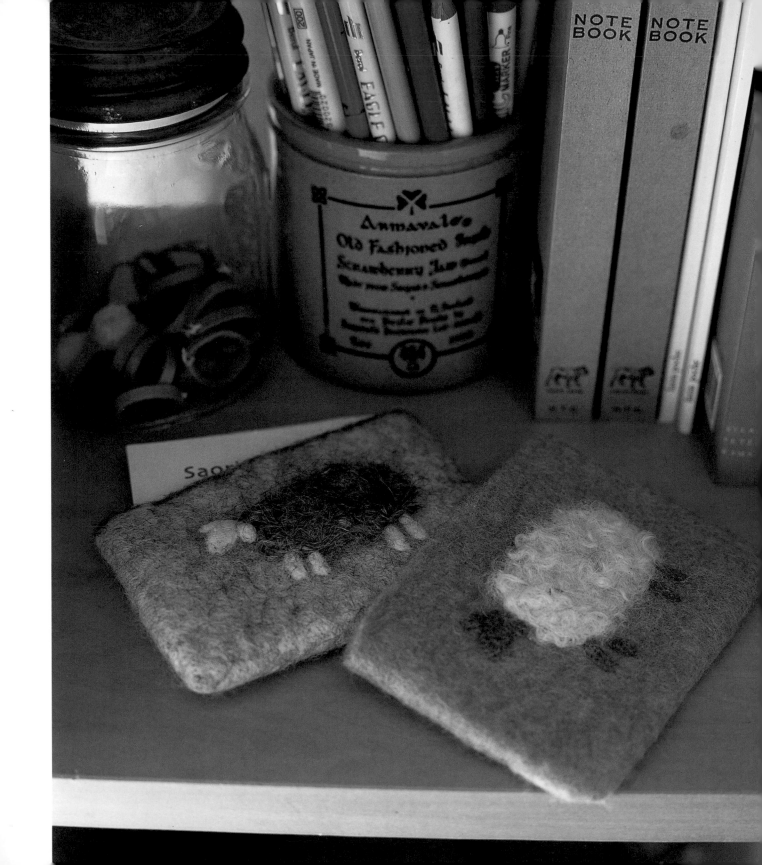

● Sheep Soft Card Case

This sheep looks like it was pulled out of a picture book. Its fluffy wool always gives me the urge to touch and feel it.

See pages 54 and 63 for pattern instructions.

I love picture books.

Of all my picture books, I especially love those that include sheep or characters who do handicraft work in the story. It makes my heart warm to feel the wool materials and to be able to create various pieces with them. I feel fortunate to be able to engage in this handicraft work.

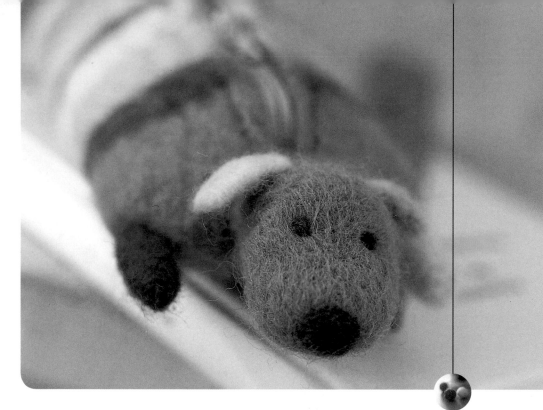

A colorful puppy.

Wool is warm and cozy, but it can also have a cool, refreshing look, especially if you use blue purplish colors as shown on this page. It's fun to make both a realistic and a whimsical puppy, as illustrated in the photos on these facing pages.

Can you imagine how a piece of fluffy felt can be transformed into a cute puppy? Don't you think felt is just wonderful?

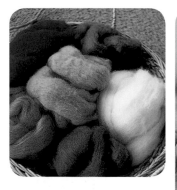

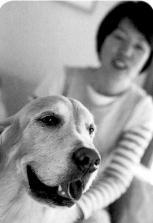

Blue Purple–Striped Doggy Pencil Case

A puppy that lies beside me like this would make me
smile even if I were engaged in serious work or study.
Knitting colorful stripes is an easy technique to master.

See page 64 for
pattern instructions.

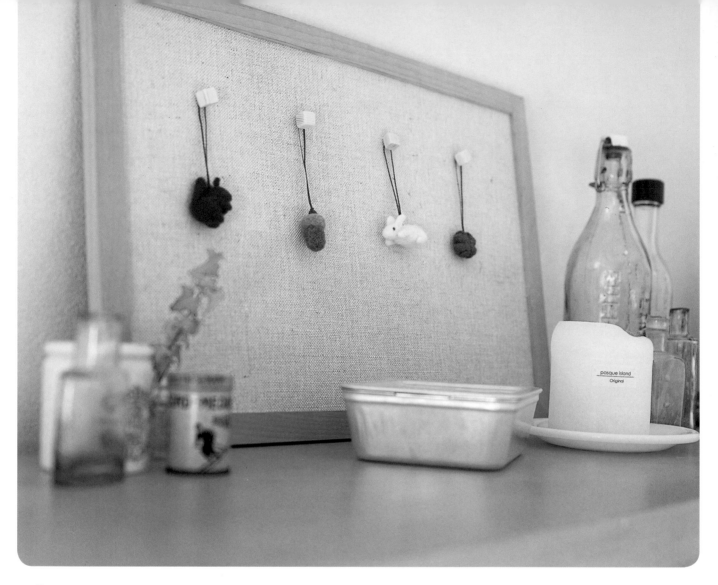

● Small Mobile Phone Charms

These are small items with cute straps that you can make with just a few strands of wool.

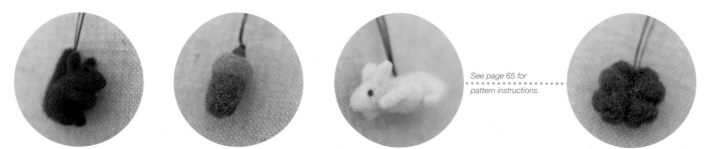

See page 65 for
pattern instructions.

● Fluffy Fish-Shaped Cushions

Felt cushions feel fluffy and tender all over. They don't need stitches or zippers because you can close them up with wool after stuffing in some cotton.

See page 66 for
pattern instructions.

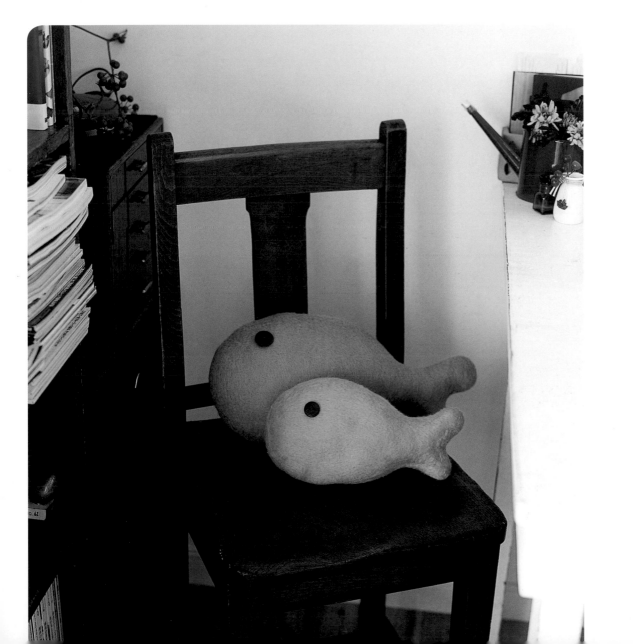

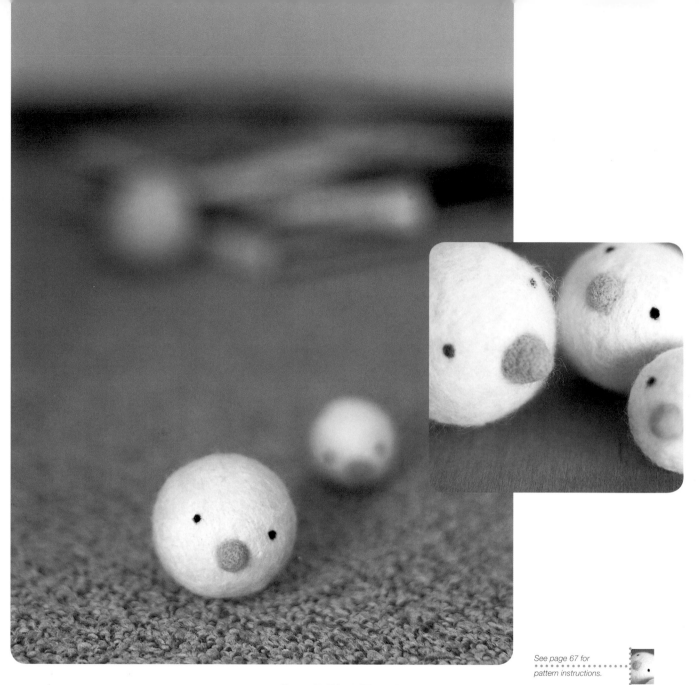

See page 67 for
pattern instructions.

Small Bird Toy Rattles

Wouldn't you like your baby to have this ball made of felt to play with? It has a rattling bell inside and your baby can roll it or chase after it.

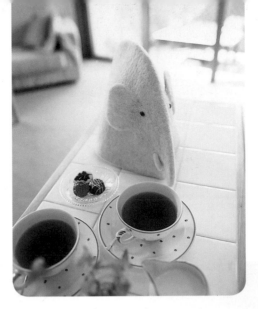

● Elephant Tea Cozy

Tea for two . . .
This cheery teapot cover makes your tea time
lovelier. Tea is kept warm for a long time when you
place this cover over your teapot.

*See page 67 for
pattern instructions.*

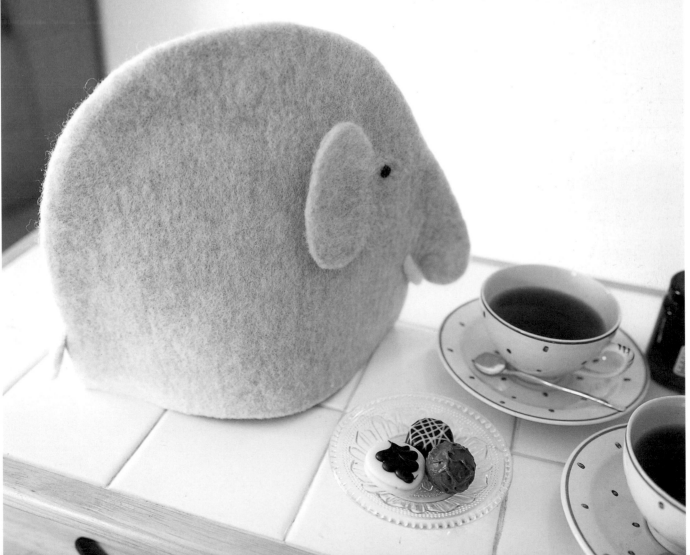

● Animal-Shaped Coasters

Making coasters is so simple that you can make as many as you want. Just place different colors of felt pieces on the top and bottom sides of the coaster pattern, then cut them out into animal shapes. It's like cutting cookies!

See page 68 for *pattern instructions.*

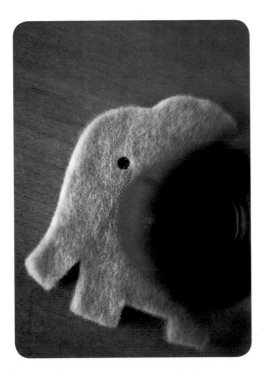

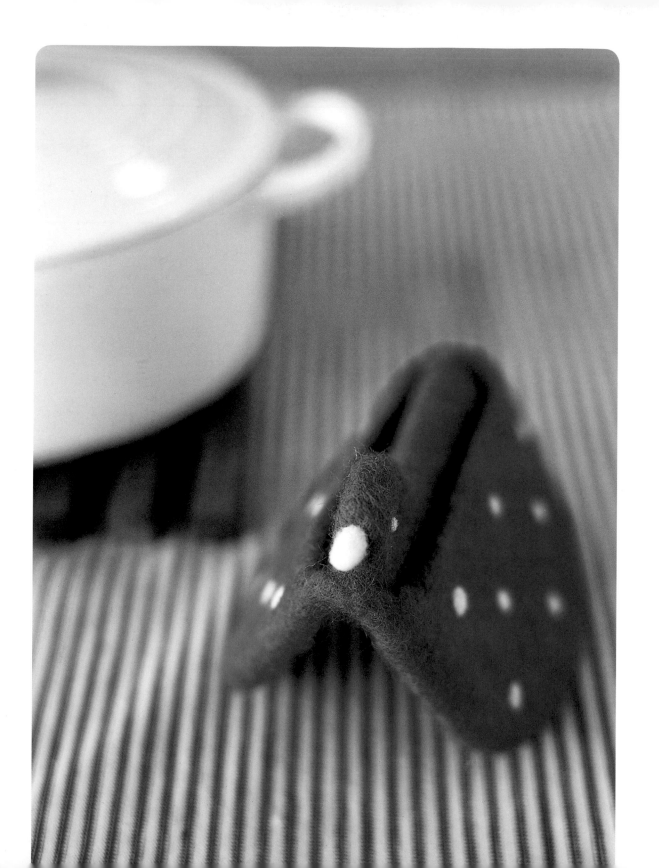

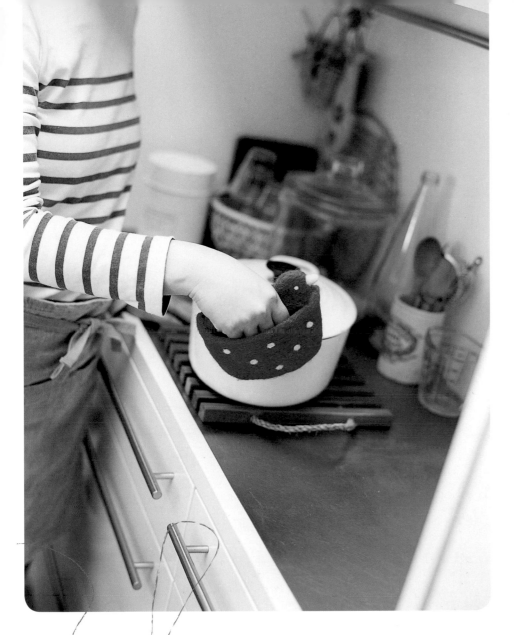

● Blue Bird Kitchen Mitten

This bright blue kitchen mitten brightens up the entire room. Its thickness provides a stable shape and is very comfortable to use.

See page 69 for
pattern instructions.

Mother and Baby Sheep

"Baa, baa, Mommy, Mommy . . ."
You can almost hear this baby sheep calling to its mother. Stuff a lot of fluffy wool in the mother sheep and less wool in the baby sheep.

See page 70 for pattern instructions.

My first encounter with a sheep.

My sister-in-law who lives in Hokkaido introduced me to felt craft. One Christmas she made me a lovely wool purse—and she found the wool on a farm. It had a fluffy and tender touch, which I always treasured. Since then, I have always been trying to create works that can make people smile when they hold them in their hands.

Thank you, sheep, for always being my models! I wish I could live with you one day.

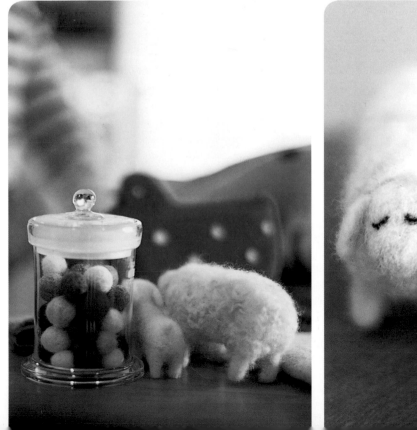

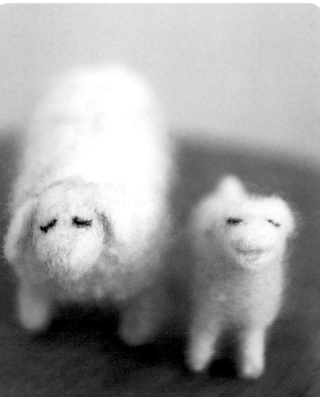

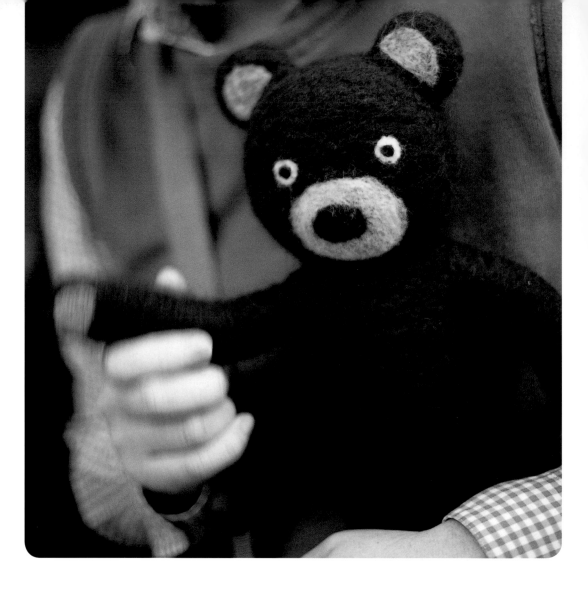

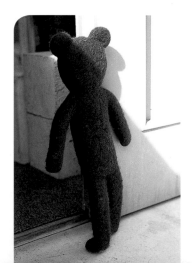

● Chocolate-Colored Bear

This chocolate-colored bear can practically stand up and walk. Making this bear is very easy, even for those who are not good at sewing.

See page 71 for
pattern instructions.

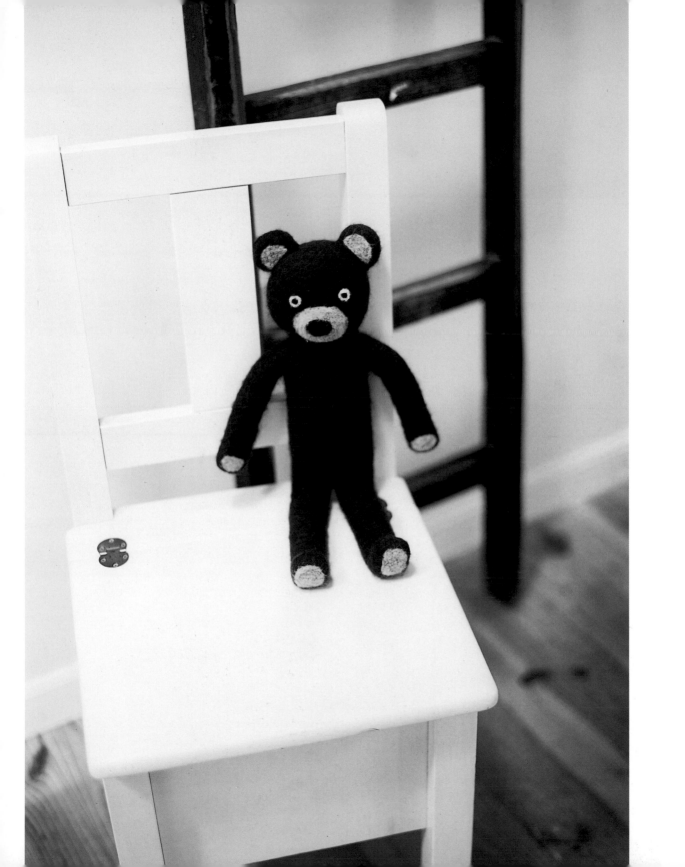

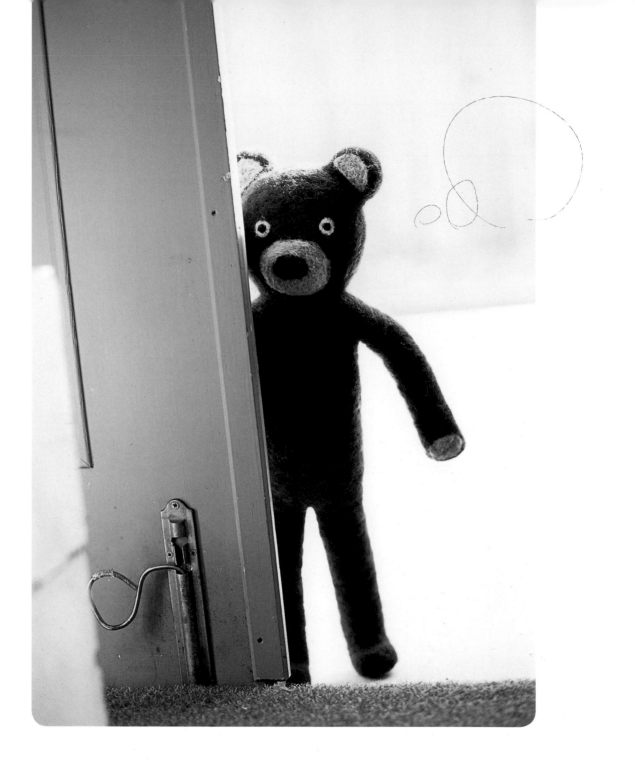

● Vickee and Co-B, Jack Russell Terriers

Have they snuck out of bed and set off for an adventure?
If the two terriers are together, they will not be afraid of going anywhere.

See page 72 for
pattern instructions.

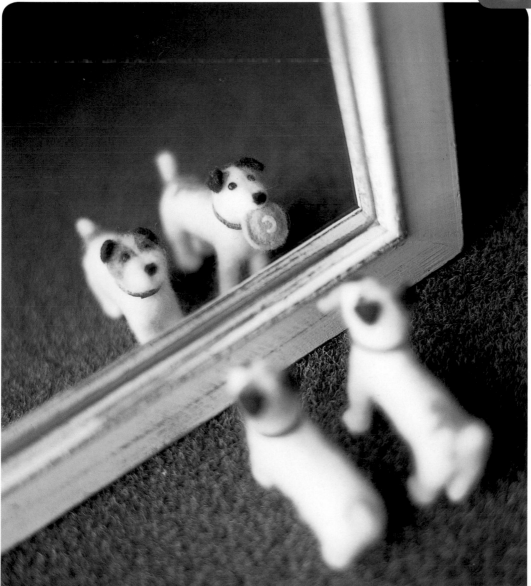

Life in Hayama.

These two dogs are modeled after real puppies. The one with a red collar is Vickee, and the other one with a blue collar is her younger brother, Co-B, who loves playing with a Frisbee. They are Jack Russell Terriers. My first look-alike puppies were modeled after my own two lovely dogs, too. I always take Vickee and Co-B for a walk around the beach in Hayama, and I make friends through my dogs. Sometimes, I make puppies that look like my friends' dogs.

In my slow daily life, surrounded by the sea and the sky, I get to know many people and learn a lot of things.

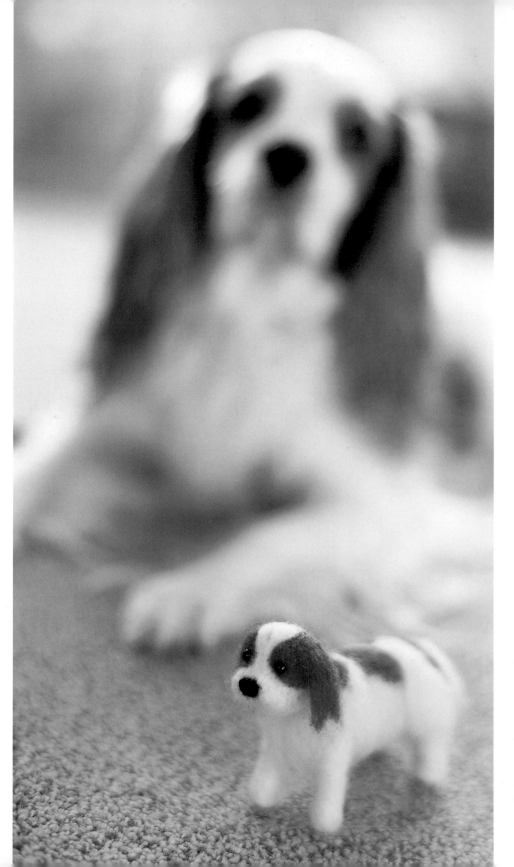

Charmy, the Cavalier

This puppy named Charmy is modeled after a member of my family. Choosing wool colors for her fluffy ears and snow-white fur and thinking about postures and facial expressions are fun things to do. Does someone in your family make you smile?

See page 73 for
pattern instructions.

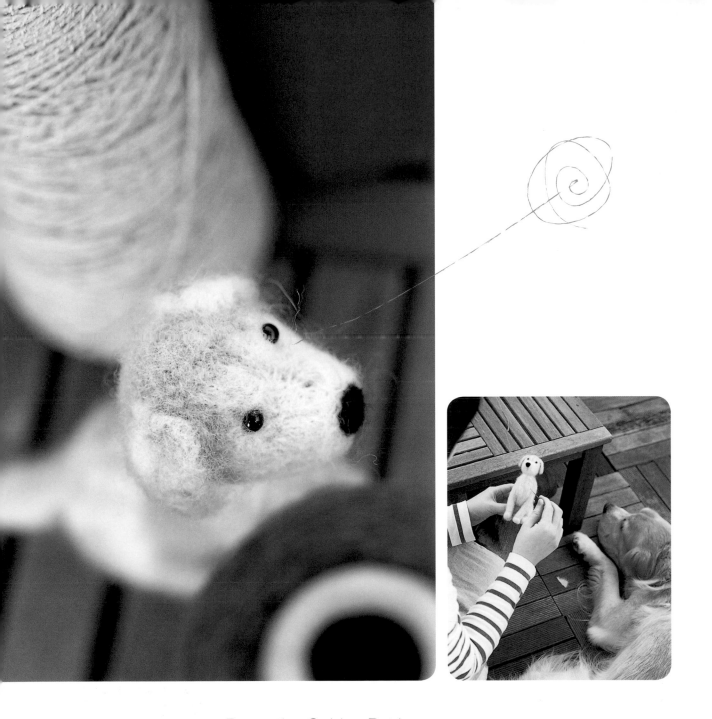

● Beau, the Golden Retriever

Beau is also a Yamazaki family member. He loves the sunny spot on the porch. He relaxes there, and sometimes looks up at me to see what I'm doing.

See page 74 for pattern instructions.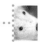

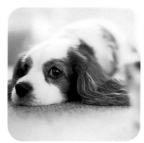

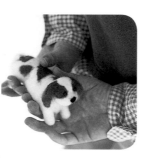

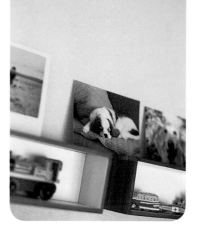

Charmy and Beau.

Recently, I have been spending more time with Charmy and Beau than with anyone else. Dependable Charmy looks cool but he is also very warmhearted. He always senses my feelings and stays close to me.

Beau is easygoing and a mama's baby. He makes everybody laugh with his funny behavior and comical expressions, and brightens up the atmosphere.

Charmy, Beau, be my best friends always, will you?

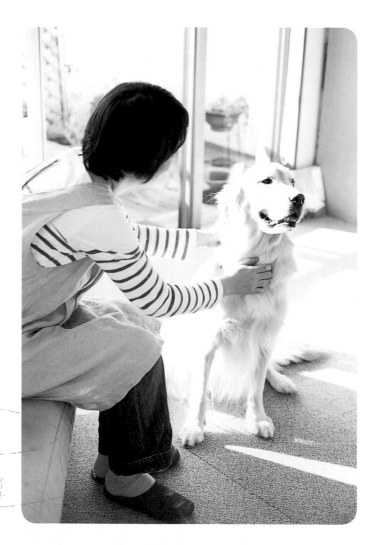

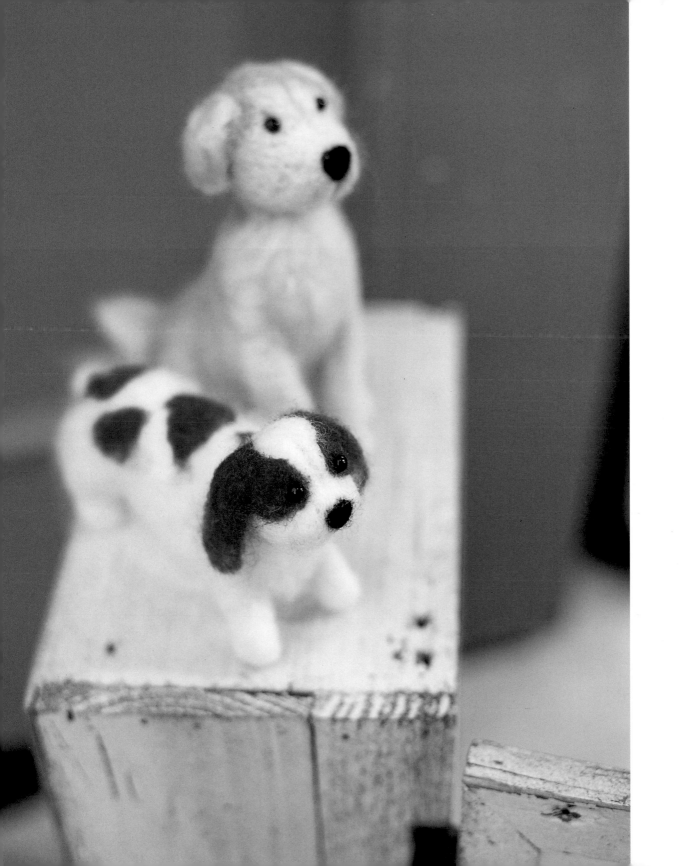

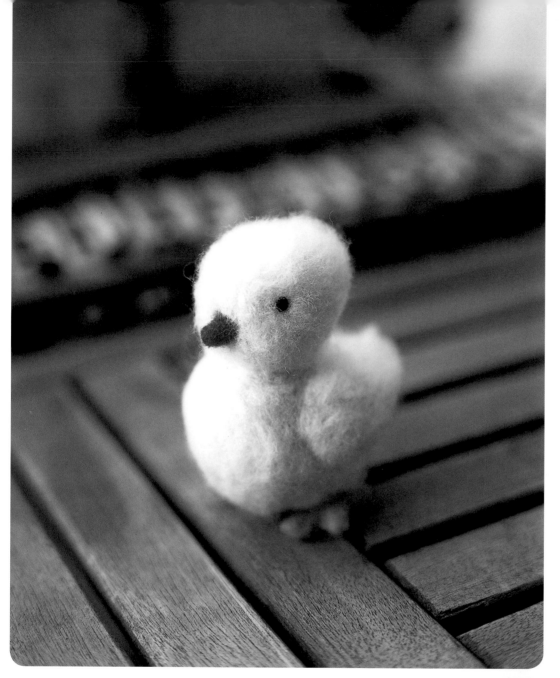

● Little Toddler Chick

This little chick toddles around, and
you can feel its warmth on your palm
while its tender feathers tickle you.

See page 75 for
• • • • • • • • • • • • • • • • • • •
pattern instructions.

● Hana, the Sheltie

Gentle-eyed Hana is now in heaven.
She has become a small piece of felt
and has come back to her owner with
lots of memories.

See page 76 for
pattern instructions.

Toy Pony

I have attached wheels to this toy pony's legs, giving it a somewhat antique and nostalgic look. It would be a perfect gift.

See pages 50 and 77 for pattern instructions.

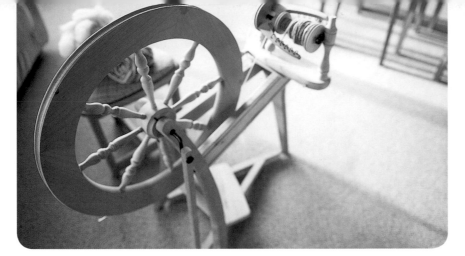

Spinning wheel.

This toy wheel rolls
vigorously just like the
spin of a real spinning
wheel. I love old crafts and
traditional handiwork.

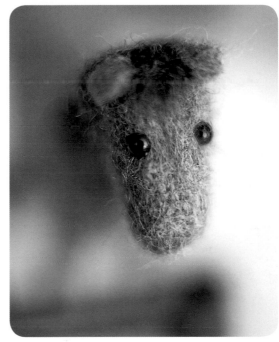

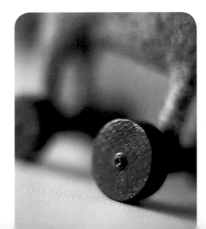

Basic Felting Method

The material used for felt work is taken from the sheep's fluffy raw wool, and comes in several types. For this book, I have used the type called "sliver," which is thoroughly washed after it is sheared and straightened in a bundle. It is easy to work with, even for beginners.

I adopted mainly two methods in this book for creating felt work. Both give shape to the felt work by intertwining the fibers of the raw wool. This process is referred to as "felting."

Needle felting
Needle felting is done by needling the raw wool firmly with a special needle called a "felting needle." This method is handy because it typically requires only one needle, and it is suitable for making solid objects, such as animals, and for designing fine patterns.

Water felting
This felting method dampens the raw wool with thin detergent, then rubs or shakes it. It adds strength and smoothness to a large piece of work or a wide surface.

This section contains instructions for making four pieces of basic and advanced patterns. Practicing with these samples will help you master the techniques needed to make all of the felted pieces in this book. In no time at all, you will begin to design your own cute patterns. Let's begin!

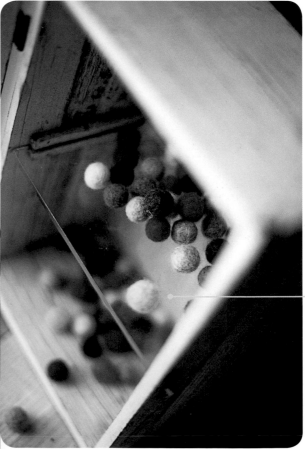

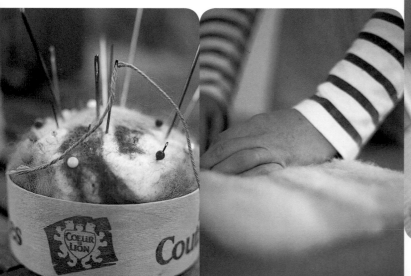

Basic Tools

• Needle felting

Felting needle

This needle is used exclusively for felting. This hardened steel needle has rough, notched edges that allow you to punch repeatedly through wool to intertwine its fibers. Multiple needles are useful when needling a broad surface. You can purchase a felting needle at any craft or hobby store.

Sponge

This is used as an underlay mat when needling your work. The types used for felting are available in many shops.

• Water felting

Bubble wrap

Used as a handmade pattern to frame and shape the wool. When making a sheet-type piece of work, raw wool is laid along the design cut out from or drawn on the sheet of bubble wrap.

Hard plastic bag

This is used to cover your hand or to place inside your work when felting so that your fingers slip easily along the material's surface.

Liquid detergent

Drop 3 or 4 drops of dishwashing detergent in about 35 oz (1 liter) of hot water. If the wool becomes lightly fizzy when rubbed, the amount of detergent used is sufficient.

Paper patterns

The paper patterns in this book include enlargement sizes; copy the patterns and use them to cut out the designs from sheets of waterproof materials, such as two bubble wraps put together with the bubble sides inside out, milk cartons, and others.

Round craft sticks

These are used to wrap and roll the raw wool for felting.

Stainless-steel pan

This is used when water felting on a table or other flat surfaces, but it is not necessary if a kitchen sink or similar unit is available.

Watering pot

This is useful for pouring small amounts of liquid detergent.

Enjoying color variation

Raw wool comes in a variety of colors. Some wools are not dyed and keep their natural colors, while others come in vivid colors, such as pink, blue, and others. Choosing colors is fun, but a tip for good color coordination is to plan ahead before starting your work. It may be a good idea to prepare many colored felt balls and use them as color samples to imagine a good color combination. Fluffy wool becomes darker when it is made into felt. Pre-made felt samples facilitate a selection of good colors that match closely with the image you have of your finished work.

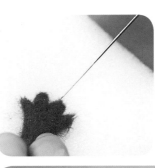

Raw wool is made into felt when its fibers are caught in the small cuts in the tip of the needle and intertwined with each other.

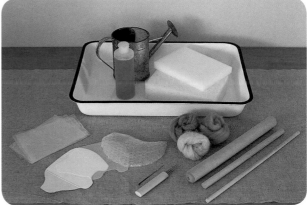

Other Tools and Materials

Digital scale

This measures raw wool accurately.

Iron

This gives a smooth finish to the felt surface for sheet-type works.

Scissors

Used to cut a piece of work. Please use sharp ones.

Sewing needle and thread

Used for sewing strings or handles onto your work.

Making a 3-D Object with Needles Only

Example: Small Bird Ornament

See page 5 for photo and page 58 for materials and diagrams.

First, make a simple ball by rolling and then needling a mass of raw wool firmly. It is possible to finish precisely the details of the 3-D object by using this basic technique.

> **LESSONS LEARNED:**
> • How to attach the eyes
> • How to attach the bill and wings
> • How to adjust the body size

Making a Felt Ball

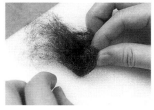

1 Take some raw wool and roll it from the edges to make a ball. Roll it as firmly as possible, then needle it firmly to make the finished round shape.

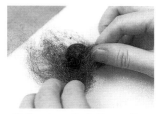

2 To enlarge the ball, wrap it with some more raw wool and wad it up. Needle it firmly to shape.

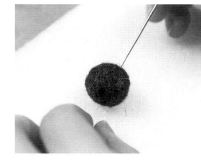

3 Needle the entire ball firmly and shape it into a perfect ball, then use the needle to firm it uniformly as much as possible. If there is any loose part in the ball, add more raw wool and needle it firmly. You will need 7 balls to make the ornament (or 21 balls if you want to hang these ornaments as pictured on page 5).

Making the Bird's Body

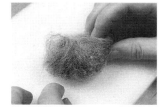

4 Wad some raw wool into an oval shape.

> **TIP:** Form a rough silhouette of the bird, using the diagram on page 58 as a guide.

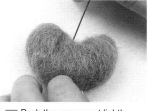

5 Push the upper part lightly with a needle to make a dent, then needle both sides firmly while adjusting the body's shape. Needle firmly from top, bottom, and sides gradually, then flatten the overall shape.

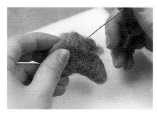

6 To enlarge the body, add some more wool evenly all over and needle it firmly. Work to intertwine the fibers until there are no loose parts.

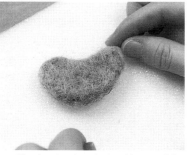

7 Shaping the piece by hand is part of the fun. Your technique will improve with practice. When you are satisfied with the shape and firmness of the body, move on to the next step.

Making the Eyes

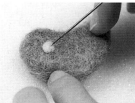

8 Wad lightly a small amount of white wool, about 0.2 in (5 mm) in diameter, while flattening and needling it to attach it to the body.

9 Place some black wool on the white part in step 8, then needle it firmly to finish the eye. You can change the bird's facial expression depending on where you locate the pupil. Repeat steps 8 and 9 to make the other eye.

Making the Bill

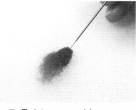

10 Twist some red-brown raw wool with the tip of your fingers and needle firmly into a cone-like shape. Leave one end loose.

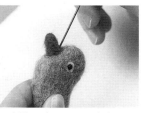

11 Place the cone made in step 10 at the position of the mouth, and needle the fluffy part into the body firmly. Make sure to needle the entire root of the bill firmly.

Making the Wings

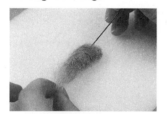

12 Needle the raw wool firmly into a flat oval shape. Shape the wings by needling from the sides (in the same way as the body), the top, and the bottom thoroughly. Leave one end loose. Make two wings.

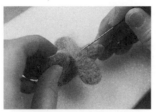

13 Place the loose part of a wing made in step 12 on the bird's back, then needle it firmly while intertwining the wing's fibers and the body's sides. Attach the other wing in the same way. Try to overcast the loose parts of both wings at the bird's back, then needle them together.

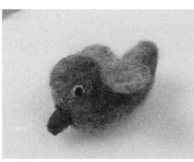

14 The bird is finished.

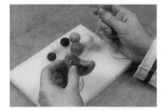

15 Pass a hemp string through the bird finished in step 14, then string the felt balls at equal intervals.

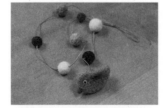

16 Make a loop at the end of the hemp string. The Small Bird Ornament is finished.

TIP: Needle in various spots and directions—top, bottom, and sides—so that the entire mass is firm and even.

Making a 3-D Object with a Core

Example: Toy Pony

See page 44 for photo and page 77 for materials and diagrams.

Wrap some raw wool around a braided wire, or the core, and make the pony's shape as real as possible. The core serves as a skeleton to raise up the animal figure firmly and allows large pieces to remain stable.

See page 44 for photo and page 77 for materials and diagrams.

> LESSONS LEARNED:
> • How to attach the neck and head
> • How to plant the hair

Making the Body

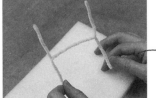

1 Carefully unravel enough wire to cross two braids at the center, then shape into a letter H, with 2.8 in (7 cm) as a horizontal bar and 2 in (5 cm) each for the four legs.

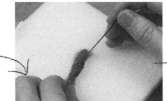

2 Form each limb. Wrap raw wool around the entire leg section, then needle it firmly.

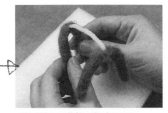

3 When all four limbs are finished, bend the piece into the pony shape as shown in the photo above.

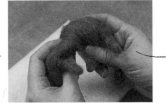

4 Wrap raw wool lengthwise, then sideways around the body.

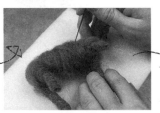

5 Needle the body firmly from top, bottom, sides, front, and back.

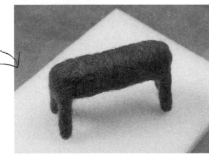

6 Firmly intertwine the body section and limbs, then shape the entire figure. When you are satisfied with the primary shape of the body, move on to the next step.

Making the Neck and Head

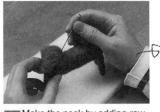

7 Make the neck by adding raw wool to the body. Needle it firmly about 1 in (2.5 cm) in diameter and 0.8 in (2 cm) in height to be able to support the head.

8 Make the head. Shape a ball into your desired size in the same way as the Small Bird Ornament (see page 48). Take your time and use the photo of the finished work as a guide to help you form the head's shape.

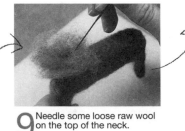

9 Needle some loose raw wool on the top of the neck.

Making the Hooves

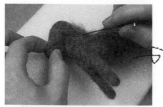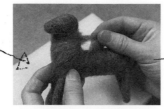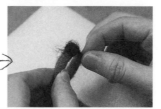

10 Place the head made in step 8 on the neck of step 9, and needle the loose parts firmly to attach them together. While needling the sides, work on felting from the neck to the head and vice versa.

11 Roll raw wool around the neck gradually while shaping it, then needle it firmly to make it stable.

TIP: The pony's neck will look more natural if you shape it thinly as you work upward and slightly incline it forward.

12 Roll and needle another color of raw wool for the hooves.

Arranging the Body Shape

Planting the Hair

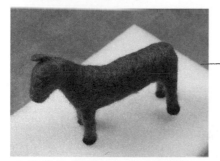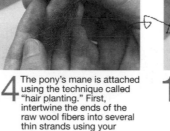

13 Shape the pony's body, puff up the chest and thighs, then needle firmly the parts that need to be thin. For the ears, make a flat oval shape in the same way as for the wings of the Small Bird Ornament (see page 49), then needle to incline slightly forward.

14 The pony's mane is attached using the technique called "hair planting." First, intertwine the ends of the raw wool fibers into several thin strands using your fingertips.

15 Align the roots of the strands made in step 14 and needle them into the neck. Arrange them so they hang on both sides of the body evenly, then trim them with scissors to adjust the length.

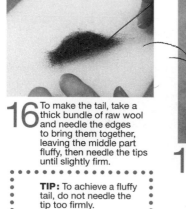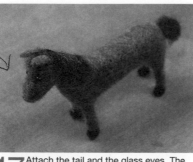

16 To make the tail, take a thick bundle of raw wool and needle the edges to bring them together, leaving the middle part fluffy, then needle the tips until slightly firm.

TIP: To achieve a fluffy tail, do not needle the tip too firmly.

17 Attach the tail and the glass eyes. The pony is finished.

Glass eyes are available at craft shops. Some types are glued or attached while others are pierced with wire.

TIP: In order to make an animal look realistic, study the photos carefully to grasp its particular features, such as the body figure, posture, hair, and more.

Basic Water Felting
Making One Sheet

Finished size: 7 in x 10 in (17 cm x 25 cm)

Lay the raw wool evenly on a flat surface in order to make a smooth sheet with constant thickness. Water felting allows you to felt larger pieces for projects such as handbags and cushions.

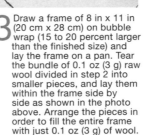

LESSONS LEARNED:
• How to arrange and lay raw wool
• How to insert patterns

Making the Body

1 Measure exactly 0.5 oz (15 g) of red raw wool for one sheet. Have ready some beige wool.

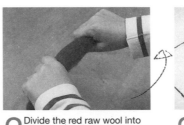

2 Divide the red raw wool into five equal parts. Measure a sliver before dividing it, and fold it into five pieces to determine the positions to be cut.

TIP: Gently separate the fibers about 2 in (5 cm) of the wool to the right and to the left of the positions to be cut. The wool will cut easily along the fold.

3 Draw a frame of 8 in x 11 in (20 cm x 28 cm) on bubble wrap (15 to 20 percent larger than the finished size) and lay the frame on a pan. Tear the bundle of 0.1 oz (3 g) raw wool divided in step 2 into smaller pieces, and lay them within the frame side by side as shown in the photo above. Arrange the pieces in order to fill the entire frame with just 0.1 oz (3 g) of wool.

TIP: Tear the wool as small as possible so that the sheet will be uniform in size.

4 If you have laid the first layer horizontally, lay the second layer vertically. Again, fill the entire second layer with just 0.1 oz (3 g) of wool, then lay the third layer horizontally again, 4th layer vertically, and 5th layer horizontally, in this consecutive pattern.

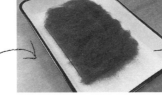

5 The 5th layer is completed.

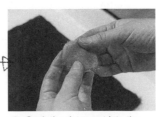

6 While holding the layered raw wool softly so as not to destroy its shape, pour the liquid detergent slowly (see page 47).

TIP: Mix the detergent with very hot water for best results. It is possible to felt with cold water, but it takes more time than felting it with hot water.

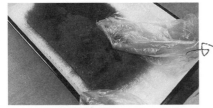

7 Cover your hand with a plastic bag and rub the detergent into the sheet entirely, while holding the sheet in place. The wool absorbs detergent well if you press or rub it softly.

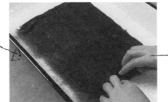

8 When the sheet has been rubbed thoroughly (as in the photo above), carefully adjust the edges to fit into the frame and arrange the thickness evenly.

9 Soak the detergent into the beige wool to make free-form designs and shape as desired while flattening the pieces.

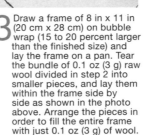

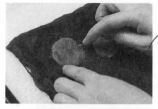

10 Place the designs on the sheet made in step 8 and rub them on the sheet with your fingers. Make sure to flatten them.

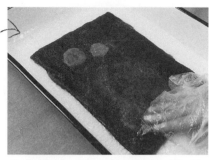

11 Rub the surface of the sheet to felt while adding a little liquid detergent. Stroke the entire surface and rub it thoroughly with gradual increased force.

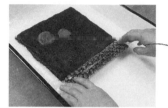

12 When the surface becomes fairly firm, roll the sheet tightly from the lower part in the bubble wrap, so it will not be loose or crooked.

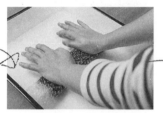

13 Press entirely while rolling softly to prevent the patterns from moving, then press a bit harder. Roll it out and straighten the wrinkles, then roll it again from the upper, right, and left parts to press it. Roll the same way on the reverse side from the upper, lower, right, and left edges. If the sheet gets dry, add liquid detergent.

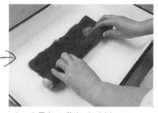

14 Take off the bubble wrap and felt it further by rolling it with a round wooden stick (see page 47). Roll it from the upper, lower, right, and left edges on both sides, and each time you roll it out, rub the surface to straighten the wrinkles. When it gets dry, add liquid detergent.

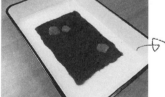

15 Repeat step 14 several times, until the felted sheet has shrunk to the desired finished size and has no wrinkles.

16 Rinse the sheet with lukewarm water, dry it in the spin dryer, then iron it. Dry it further in the air, and a "sheet" is completed. The edges can be finished by trimming with scissors.

TIP: The basic method of felting wool into a sheet is to alternate the layers of raw wool vertically and horizontally. By doing so, the fibers intertwine with each other sufficiently to create a strong and smooth finish.

Making a Sheet into a Bag

Example: Sheep Soft Card Case

See page 19 for photo and page 63 for materials and diagrams.

Insert a pattern between two sheets to felt the raw wool into a bag. This technique is used for bags, pouches, cushions and other similar objects. In this lesson, we will make patterns using a needle.

See page 19 for photo and page 63 for materials and diagrams.

> LESSONS LEARNED:
> • How to change colors for the inner and outer parts
> • How to attach designs or patterns with a needle

 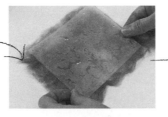 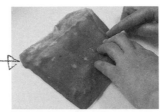

1 Divide 0.2 oz (6 g) of beige raw wool into four pieces in the same way for making a sheet and place one of the pieces on a 4 in x 5 in (10 cm x 13 cm) wool pattern horizontally. Tear softly with your hands to lay the fibers uniformly. Form a square larger than the pattern (see page 52 for more detail).

2 Place the second layer vertically on the layer made in step 1 and add liquid detergent slowly. Press the entire sheet lightly so that the detergent is soaked in, then take out the pattern and place it on the raw wool again.

3 Fold over the excess fabric.

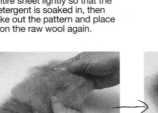

4 Repeat the steps to form two layers on either side of the bubble wrap pattern. (There are two layers on both sides of the pattern. For both sides, the first layer is vertical and the second is horizontal.)

5 Let the sheet in step 4 absorb the liquid detergent well and turn it upside down altogether. Then, fold the excess that sticks out in order to shape it. Now four layers wrap the pattern in the center.

> **TIP:** Corners and edges become firm if they absorb the detergent well.

6 Divide 0.2 oz (6 g) of brown raw wool into four pieces and place one of them vertically on the sheet made in step 5. Place the second layer horizontally, then continue in the same way for steps 2 to 5. There will be four layers on each side in two colors: beige on the inside and brown on the outside—now eight layers that wrap the pattern in the center.

7 While adding the liquid detergent, stroke and rub the entire sheet lightly to felt it further. Let the edges absorb the liquid well.

> **TIP:** Press softly first, then press the internal layers harder. It is good to rub softly with your fingertips.

8 The work is finished when you feel the sheet packed with fiber inside while pinching the surface slightly. If it is not felted enough, the fiber becomes loose and may partially fall out.

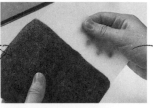

10 Pull out the bubble wrap pattern.

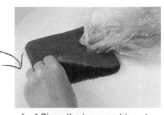

11 Since the inner part is not yet felted enough, turn the bag inside out carefully so as not to destroy its shape (the beige side comes out). Then, felt it in the same way as in step 7.

9 Cut out one side of the sheet with scissors to make the mouth for inserting the cards.

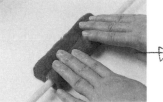

12 As done for the single sheet (see page 53), roll the sheet with a round stick to felt it. Roll it tightly on both sides from the upper, lower, right, and left sides. Each time you roll it out, straighten the wrinkles by rubbing it, and when it gets dry, add liquid detergent. Keep the open edges of the mouth aligned while felting.

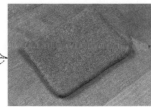

13 As you felt the bag further, it achieves the finished size. Rinse it with lukewarm water, then dry it lightly in a spin dryer and iron it. Leave it to dry in the air.

14 Lay the sheep design with a felting needle. Insert a felting sponge into the bag as an underlay, and form the fluffy body part by needling it.

15 Needle the oval-shaped face, then form the ears and legs.

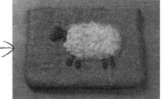

16 The Sheep Soft Card Case is complete.

TIP: The basic technique for making a bag is to form the same number of layers on both sides of the pattern and then connect the edges. Felt the sheet thoroughly on the outside and inside, then finish it firmly.

When working on small details:

This method is recommend when working on details with a needle, such as the limbs, claws, and an open mouth of an animal piece.

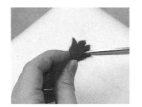

Needle and shape a paw into a ball and then cut the correct number of fingers with scissors.

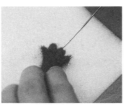

Needle the fingers firmly and gradually to shape the design.

If the trace of needling stands out:

While needle felting your work, the holes made by the needle sometimes stand out on the surface. In such a case, soak your work in some water and rub it softly with your fingers. You can also poke it with a toothbrush to erase the holes. If you rub it too strongly, it may fuzz unnaturally, so you need to be very careful.

When mending an unsuccessful work or broken part:

One of the greatest characteristics of felt work is that it is easy to mend. Most problems are solved by needling it or adding raw wool to reinforce the work. It is advisable to save some extra raw wool for mending so that you will be able to enjoy your precious work for a long time.

When the work lacks volume:
Add a bit of raw wool in the part that lacks volume and needle it.

When the work has excess volume:
Cut out the unnecessary parts with scissors and smooth the surface with a needle.

When a bag becomes partially thin:
Mend by needling raw wool of the same color onto the reverse side.

When the animal's limbs almost come off:
Reinforce the limbs by adding and needling a proper amount of raw wool.

When making adjustments with hair planting:
Make adjustments by adding and pulling out some raw wool.

When you do not like the positions of the ears or eyes:
Pull off the parts slowly and smooth the surface, then re-place the ears or eyes on the desired locations.

Instructional Guide

- The symbol \int represents those works that use needle felting, and the symbol ♦ represents those works that use water felting. Refer to page 47 for the required tools for both methods.

- The required amount of raw wool varies depending on the degree of strength applied for felting. The indicated amounts in this book allow for a little extra wool.

- All the dimensions in the figures represent the finished pattern sizes.

- Sewing needles and pins may also be used, but I used the simple term "needle" to describe a felting needle, as opposed to other kinds of needles.

- The patterns in reduced sizes are displayed for works that have special shapes. For those works that do not have special shapes, cut out circles or rectangles according to the indicated sizes.

- If you get lost in the process and are not sure about the working details, refer to the photos on pages 48–55 and review the methods.

- Raw wool is available in general stores or handicraft shops.

● Small Bird Ornament

See pages 4–5 for photos.

Materials

Raw wool
Bird and felt balls, 5 colors: Light brown, 0.2 oz (5 g); White, Light gray, Golden brown, Brown, a little

Sclera (white part of the eyes): White, a little

Pupil: Black, a little

Bill: Red and Brown, a little

Hemp string, 0.04 in x 35 in (1 mm x 90 cm)

Steps

This work is also explained with photos on page 48.

1 Make 7 felt balls as shown in the diagram: 2 large balls, 1 in (2.5 cm) diameter; 3 medium balls, 0.8 in (2 cm) diameter; 2 small balls, 0.7 in (1.7 cm) diameter.

2 Make the body of the bird, then attach the eyes, bill, and wings in order.

3 Pass a hemp string through the back of the bird and string the balls to finish the work, as shown in the diagram.

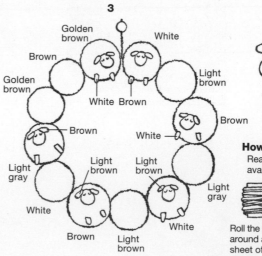

2

1 in (2.5 cm)

0.4 in (1 cm) thick

2.4 in (6 cm)

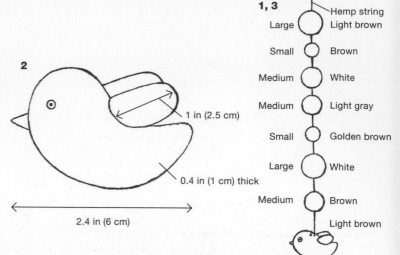

1, 3

Large	Hemp string / Light brown
Small	Brown
Medium	White
Medium	Light gray
Small	Golden brown
Large	White
Medium	Brown
	Light brown

● Sleepy Sheep Wreath

See pages 6–7 for photos.

Materials

Raw wool
Body, 5 colors: White, 0.7 oz (20 g); Light gray, 0.5 oz (15 g); Light brown, 0.5 oz (15 g); Golden brown, 0.5 oz (15 g); Brown, 0.7 oz (20 g)

Eyes: Black, a little

Wire: Silver, 0.04 in x 28 in (1 mm x 70 cm)

Thick string (e.g. kite thread), a little

Steps

1 Make 12 pom-poms of 1.6 in (4 cm) in diameter: white, 3; light gray, 2; light brown, 2; golden brown, 2; brown, 3.

2 Place the face and the front limbs of the sheep on six of the pom-poms made in step 1.

3 Cut the wire's end at an angle (to pierce it through the pom-poms), and connect the ends to make it into a circle. Position the balls with the faces appearing on the same side. Hook and twist both ends of the wire to finish.

3

Golden brown
White
Brown
Golden brown
White Brown
Light brown
Brown
White
Brown
Light gray
Light brown
Light brown
Light gray
White
Light brown
White
Brown
Light brown

1, 2

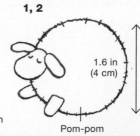

1.6 in (4 cm)

Pom-pom

How to make the pom-poms

Ready-made pom-poms are also available at stores.

Roll the raw wool around a small sheet of 2.4 in (6 cm) wide cardboard.

Pull out the cardboard and tie the roll at the center with a kite thread or other thick string. Trim and shape both ends into a round shape.

● Mouse Pincushions

See pages 8–9 for photos.

Materials

Raw wool
Large gray body: Light gray,
0.3 oz (8 g)

Large brown body: Golden brown,
0.3 oz (8 g)

Eyes and nose: Black, a little

Strings for the whiskers: Superfine
black, 4 in (10 cm) each

(The small mouse is made from
0.1 oz (3 g) of raw wool in the
same way as the large mouse.)

Steps

1 Make an egg-shaped body, needle it firmly to make a thin nose tip, and flatten the bottom side.

2 Attach the ears onto the head and a thin, long tail onto the buttocks.

3 Attach the round or line eyes and a nose.

4 Use two-stranded strings for the whiskers; sew through the nose tip. Trim to adjust the length and attach with glue at the base to finish.

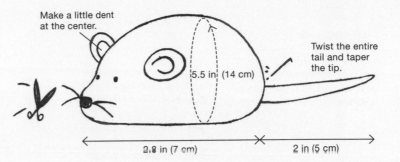

Make a little dent at the center.

5.5 in (14 cm)

Twist the entire tail and taper the tip.

2.8 in (7 cm) 2 in (5 cm)

● Pink Gecko Magnet

See page 10 for photo.

Materials

Raw wool
Body: Strawberry red, 0.4 oz
(10 g)

Magnet, 1: 0.8 inch (2 cm)

Steps

1 Shape the felt into a long, thin gourd shape and flatten it slightly to make the head and the body.

2 Make the limbs and the tail separately and needle to attach them on the body made in step 1.

3 Place a magnet inside the stomach area to finish.

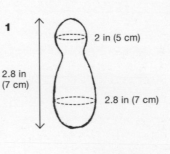

1

2 in (5 cm)

2.8 in (7 cm)

2.8 in (7 cm)

Cut the tips of the gecko's hands into 4 parts and make a round shape (see page 56).

2

2 in (5 cm)

Taper the tip of the tail.

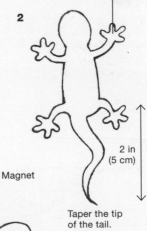

Needle a piece of wool of the same size firmly over the magnet.

Magnet

3

Stomach

● Rabbit-Shaped Plate

See page 11 for photo.

Materials

Raw wool
Tray: Natural wool color, 0.5 oz (15 g)

Ears: Natural wool color, a little

3

Use a bowl with an inner diameter of about 4 in (10 cm) to form a round bottom.

1 in
(2.5 cm)

Side section

4

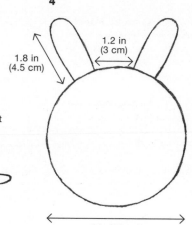

1.2 in
(3 cm)

1.8 in
(4.5 cm)

4 in (10 cm)

Steps

1 Divide the raw wool into 6 pieces for the tray.

2 Place one piece of wool within a frame drawn on bubble wrap in a circle 4.7 in (12 cm) in diameter, then place the other 5 layers in horizontal and vertical directions alternately. Pour liquid detergent over every 2 layers until they are well absorbed, then adjust the shape along the pattern while felting.

3 Press the sheet on a bowl or a round-bottomed container to create roundness, then dry well.

4 Needle wool firmly into the shape of the ears and place them on the edge of the tray made in step 3.

● Bird Pouch

See page 12 for photo.

Materials

Raw wool
Body: Light brown, 0.7 oz (20 g)

Sclera (white part of the eye): White, a little

Pupil: Black, a little

Bill: Red and brown, a little

Wings: Brown, a little

Zipper, 1: Pale brown, 6 in (15 cm)

5

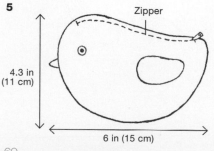

Zipper

4.3 in
(11 cm)

6 in (15 cm)

Steps

1 Divide the raw wool into 8 pieces for the body.

2 Lay two of the pieces made in step 1 (2 layers) on the pattern, in vertical then horizontal directions alternately, and pour liquid detergent until well absorbed.

3 Repeat step 2 on the other side of the pattern; lay another pair of layers on the layer made in step 2. Let the layer absorb liquid detergent. Wrap the pattern with 4 layers altogether on both sides to form a bag (see page 54).

4 Cut the zipper path open and pull out the pattern. Turn the pouch inside out, then felt it until you attain the sizes indicated in the diagram. Felt the cut part and the edges very well.

5 Spin dry and iron to dry well. Needle the eyes, bill, and wings, then sew on the zipper to finish.

Pattern (Enlarge by 230 percent.)

● Piglet Pouch

See page 13 for photo.

Materials

Raw wool
Body: Natural wool color, 0.8 oz (24 g)

Eyes: Brown, a little

Ears and tail: Natural wool color, a little

Zipper, 1: Natural wool color, 6 in (15 cm)

Steps

1 Divide the raw wool into 8 pieces for the body.

2 Lay two of the pieces made in step 1 (2 layers) on the pattern, in vertical then horizontal directions alternately, and pour liquid detergent until well absorbed.

3 Repeat step 2 on the other side of the pattern; lay another pair of layers on the layer made in step 2. Let the layer absorb the liquid detergent. Wrap the pattern with 4 layers on both sides in order to form a bag (see page 54).

4 Cut the zipper path open and pull out the pattern. Turn the pouch inside out, then felt it until you attain the sizes indicated in the diagram. Felt the cut part and the edges very well.

5 Spin dry and iron to dry well. Needle the eyes, ears, and tail, then sew on the zipper to finish.

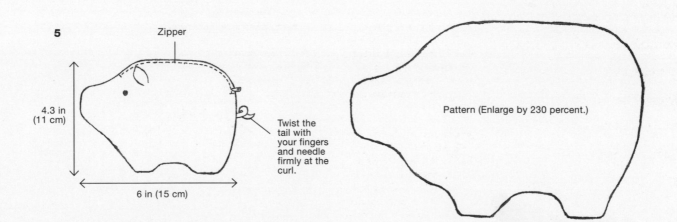

5

Zipper

4.3 in (11 cm)

6 in (15 cm)

Twist the tail with your fingers and needle firmly at the curl.

Pattern (Enlarge by 230 percent.)

● Giraffe and Zebra Bags for Taking a Stroll

See pages 14–17 for photo.

Materials

• Giraffe
Raw wool
Body: Corn, 2.1 oz (60 g)

Design: Red and brown, 0.3 oz (8 g)

Leather belt: Brown, 0.4 in x 23.6 in (1 cm x 60 cm)

• Zebra
Raw wool
Body: Natural wool color, 2.1 oz (60 g)

Design: Charcoal gray, 0.2 oz (5 g)

Leather belt: Black, 0.4 in x 23.6 in (1 cm x 60 cm)

Steps

1 Divide the raw wool into 8 pieces for the body.

2 Lay two of the pieces made in step 1 (2 layers) on an 8 in x 9.8 in (20 cm × 25 cm) rectangle-shape pattern, first in vertical then horizontal directions alternately, and pour liquid detergent until well absorbed. Then, take the raw wool for the design (arrange in a pan as per the diagram) and pour liquid detergent until well absorbed.

3 Take out the pattern and lay it over the sheet made in step 2; position the design and connect to the side made in step 2, then lay the remaining body pieces, keeping horizontally and vertically and press, keeping the design as the outer layer.

4 Make 4 layers on each side in order to form a bag (see page 54).

5 Cut out the bag's mouth and pull out the pattern. Turn the bag inside out, then felt it until it attains the sizes indicated in the diagram. Felt the cut part and the edges very well.

6 Spin dry and iron to dry well. Cut the belt into 11.8 in (30 cm) lengths and sew on the leather handles to finish.

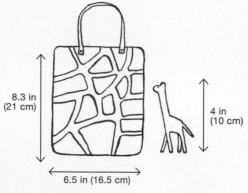

Giraffe's mascot

Make the body with the same raw wool used in the bag and attach the tail, limbs, and neck. (See page 74: Beau, the Golden Retriever, for step-by-step instructions.)

8.3 in (21 cm)

6.5 in (16.5 cm)

4 in (10 cm)

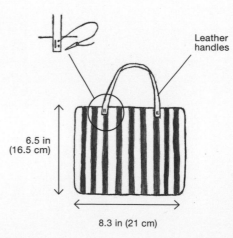

Leather handles

6.5 in (16.5 cm)

8.3 in (21 cm)

● Sheep Soft Card Case

See pages 18–19 for photos.

Materials

Raw wool
Body (front side): Caramel or beige color, 0.2 oz (6 g)

Body (back side): Brown, 0.2 oz (6 g)

Sheep's head and limbs: Brown, a little

Sheep's body: White curly wool, a little

Steps

This work is also explained with photos on page 54.

1 Divide the raw wool into 4 pieces for the front and back sides.

2 Lay the two pieces for the front side made in step 1 (2 layers) on a 4 in x 5 in (10 cm × 13 cm) rectangular pattern, first in vertical then horizontal directions alternately, and add liquid detergent until well absorbed. Repeat for the other side of the sheet and felt so that the pattern is wrapped by the felt.

3 Lay another pair of layers for the back side on the layer made in step 2 and let the layers absorb the liquid detergent, wrapping the pattern with 4 layers on each side in order to form a bag (see page 54).

4 Cut out the mouth of the bag with scissors and remove the pattern. Turn it inside out then felt it until it attains the finished sizes shown in the diagram. Felt the cut part and the edges well.

5 Spin dry and iron to dry well, then allow to further air dry. Needle the sheep design to finish.

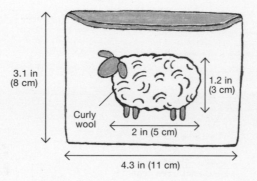

3.1 in (8 cm)

1.2 in (3 cm)

Curly wool

2 in (5 cm)

4.3 in (11 cm)

● Blue Purple-Striped Doggy Pencil Case

See pages 20–21 for photos.

Materials

Raw wool
Body and head: (A) Bubble gum color, 0.7 oz (20 g)

Face: Blueberry blue, a little

Other parts: (B) Blueberry blue, (C) Cream, (D) Yellow green, 0.1–0.2 oz (3–5 g) each

Zipper, 1: Sky blue, 6.3 in (16 cm)

Steps

1 Divide the raw wool into 8 pieces for the body (A).

2 Lay two of the pieces made in step 1, first in horizontal then vertical directions (2 layers), and lay the wool (B), (C), and (D) in stripes over them. Wrap an 8 in x 4 in (20 cm x 10 cm) pattern while pouring liquid detergent, then rub until the detergent is well absorbed.

3 Lay the remaining pieces in step 1 over the sheet made in step 2, and press well. Lay 4 layers on each side alternately, making 8 layers total to make the bag (see page 54), then felt well.

4 Cut out the zipper path with scissors and pull out the pattern. Turn inside out, then felt until the piece attains the sizes indicated in the diagram below.

5 Spin dry and iron to dry well. Needle the head, face, and limbs, then sew on the zipper to finish.

Pattern for steps 2 and 3

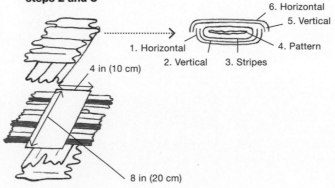

6. Horizontal
5. Vertical
1. Horizontal
4. Pattern
2. Vertical
3. Stripes
4 in (10 cm)
8 in (20 cm)

4, 5

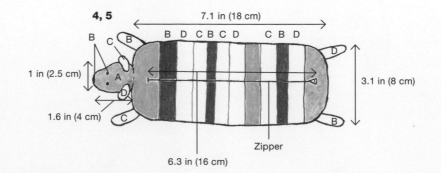

7.1 in (18 cm)
B D C B C D C B D
B C B
1 in (2.5 cm)
A
D
3.1 in (8 cm)
D
1.6 in (4 cm)
C
B
Zipper
6.3 in (16 cm)

● Small Mobile Phone Charms

See page 22 for photos.

Materials

• Rabbit
Raw wool
Body: Natural wool color, 0.1 oz (2 g)
Eyes: Red, a little

• Acorn
Raw wool
Caramel brown, Brown, 0.05 oz each (1 g)

• Squirrel
Raw wool
Body: Nutmeg color, 0.1 oz (2 g)
Eyes: Black, a little

• Clover
Raw wool
Kiwi green, 0.05 oz (1 g)

Strings: Brown, 8 in (20 cm) each

Wooden bead, 1: Brown

Steps

1 Make the bodies and the details as shown in the diagrams, then shape them while needling firmly (see page 48).

2 Pass a string through the bodies with a sewing needle and hide the node to finish.

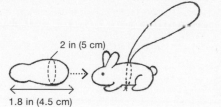

2 in (5 cm)

1.8 in (4.5 cm)

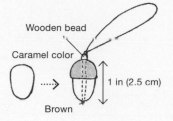

Wooden bead

Caramel color

Brown

1 in (2.5 cm)

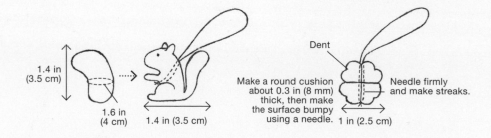

1.4 in (3.5 cm)

1.6 in (4 cm)

1.4 in (3.5 cm)

Dent

Make a round cushion about 0.3 in (8 mm) thick, then make the surface bumpy using a needle.

Needle firmly and make streaks.

1 in (2.5 cm)

● Fluffy Fish-Shaped Cushions

See page 23 for photo.

• • • • • • • • • • • • • • • • • •

Materials

Raw wool
Large: Olive-green, 2.8 oz (80 g), and
a little for closing the cut part

Small: Yellow, 1.8 oz (50 g), and a
little for closing the cut part

Buttons: 1 large, 1 in (2.5 cm)
diameter; 1 small, 0.8 in (2 cm)
diameter

Handicraft stuffing cotton: a few
handfuls

Steps

1 Divide the raw wool into 8 pieces.

2 Lay two of the pieces made in step 1 (2 layers) on the pattern, first in vertical then horizontal directions alternately, and pour liquid detergent until well absorbed.

3 Repeat step 2 on the other side of the pattern, lay another pair of layers on the layer made in step 2, let them absorb the detergent. Wrap the pattern with 4 layers on both sides to form a bag (see page 54).

4 Cut along the edges with scissors to make an opening just big enough to pull out the pattern. Turn the bag inside out, then felt until it attains the finished size. Felt the edges very well.

5 Spin dry and iron to dry well. Then, stuff the cotton through the opening, add raw wool in the opening, and close with a needle.

6 Sew on buttons for the eyes to finish.

Pattern (Enlarge by 400 percent for
large, 300 percent for small.)

Finished sizes
Large: 15.7 in x 8.7 in (40 cm x 22 cm)
Small: 11.8 in x 6.7 in (30 cm x 17 cm)

● Small Bird Toy Rattles

See page 24 for photo.

Materials

Raw wool
Body: Cream, 2 oz (60 g) for large;
1.3 oz (36 g) for medium, 0.6 oz (17 g)
for small

Bill: Cheesecake color, a little

Eyes: Black, a little

Plastic bell, 1 each: 1.4 in (3.5 cm)
diameter for large and medium; 1 in
(2.5 cm) diameter for small

Steps

1 Wrap the raw wool for the body around the plastic bell. Pour liquid detergent, gradually increasing the body's volume (see page 46).

2 Put the body made in step 1 into a plastic bag and roll and rub with your fingers while maintaining its shape in order to felt it according to the sizes indicated in the diagram.

3 Dry well and attach the eyes and bill with a needle to finish.

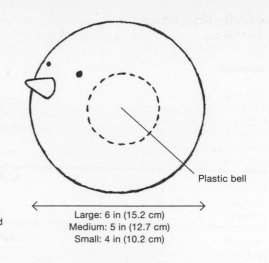

Plastic bell

Large: 6 in (15.2 cm)
Medium: 5 in (12.7 cm)
Small: 4 in (10.2 cm)

● Elephant Tea Cozy

See page 25 for photo.

Materials

Raw wool
Body: Beige, 2.8 oz (80 g)

Eyes: Solid color (Brown), a little

Ears and tail: Beige, a little

Tusk: Natural wool color, a little

Steps

1 Divide the raw wool into 8 pieces for the body.

2 Lay two of the pieces made in step 1 (2 layers) on the pattern, first in vertical then horizontal directions alternately, and pour liquid detergent until well absorbed.

3 Repeat step 2 for the reverse side, then lay another pair of layers on the layer made in step 2 and let them absorb the liquid detergent. Wrap the pattern with 4 layers on both sides to form a bag (see page 54).

4 Cut out the bottom edge and pull out the pattern. Turn inside out, then felt the body until it attains the sizes indicated in the diagram. Felt the cut part and edges very well.

5 Spin dry and iron to dry well. Needle the eyes, ears, tusks, and tail to finish.

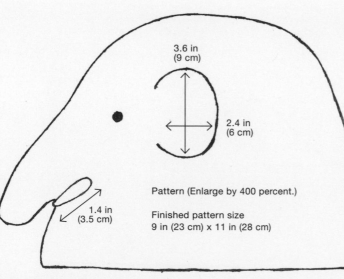

3.6 in (9 cm)

2.4 in (6 cm)

1.4 in (3.5 cm)

Pattern (Enlarge by 400 percent.)

Finished pattern size
9 in (23 cm) x 11 in (28 cm)

1.2 in (3 cm)

● Animal-Shaped Coasters

See pages 26–27 for photos.

Materials

Raw wool
Front: Beige, 0.5 oz (15 g)

Back: Brown, 0.5 oz (15 g)

Steps

1 Divide both colored raw wools into 3 pieces each.

2 Lay three layers of the beige wool divided in step 3 vertically, horizontally, and vertically again, then lay three layers of the brown wool horizontally, vertically, and horizontally (see page 52).

3 Pour liquid detergent on the sheet made in step 2 until well absorbed, then felt it until it attains a size of about 8.3 in x 11.8 in (21 cm × 30 cm).

4 Spin dry the sheet made in step 3 and iron to dry well, then pin it on the pattern to cut out the shapes. Punch holes to make the eyes, and the work is finished.

4 Pattern (Enlarge by 300 percent.)

● Blue Bird Kitchen Mitten

See pages 28–29 for photos.

Materials

Raw wool
Body: Lagoon color, 1.8 oz (50 g) for the body; 0.2 oz (6 g) for the head

Eyes, bill, and polka dot design: Natural wool color, a little

Steps

1 Divide the raw wool into 8 pieces for the body.

2 Lay two of the pieces made in step 1 (2 layers) on an 8.7 in x 6.3 in (22 cm × 16 cm) oval pattern, first in vertical then horizontal directions alternately, then pour liquid detergent until well absorbed.

3 Repeat step 2 on the reverse side, lay another pair of layers on the layer made in step 2, then let them absorb the detergent. Wrap the pattern with the 4 layers on both sides to form a bag (see page 54).

4 Cut along line A with scissors to pull out the pattern. Turn the piece inside out and felt until the mitten attains the finished size.

5 Cut along line B (do not cut both sides of the bag), pour liquid detergent on the cut part, then rub until well absorbed.

6 Spin dry very well, then iron and press hard to mark the creases. Attach the head, eyes, bill, and polka dot design with a needle to finish.

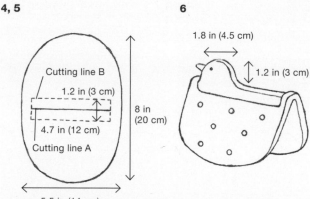

4, 5

Cutting line B
1.2 in (3 cm)
4.7 in (12 cm)
Cutting line A
8 in (20 cm)
5.5 in (14 cm)

6

1.8 in (4.5 cm)
1.2 in (3 cm)

● Mother and Baby Sheep

See page 30 for photo.
.

Materials

Raw wool
Body: White, 0.4 oz (10 g) for the
mother; 0.2 oz (5 g) for the baby

Body surface: White curly wool, a
little for the mother

Ears: White, a little

Eyes: Black, a little

Braid, 2 pieces: 9.8 in (25 cm) each
for the mother; 5 in (13 cm) each for
the baby

Steps

• Mother

1 Make the core of the body with 2 braids, wrap the raw wool around the baby, then form the limbs and the body firmly (see page 50).

2 Make the head and attach it to the body, then attach the eyes and ears.

3 Wrap the the body softly with the raw wool and needle to achieve the desired shape, then attach the curly wool on the surface with a needle to finish.

• Baby

1 Make the limbs and the body in the same way as for the mother, starting with smaller braids.

2 Make the head and attach it to the body, while needling the neck firmly. Cut out the mouth opening with scissors and needle it firmly to shape it. Attach eyes and ears.

3 Attach a thin layer of raw wool on the body to finish.

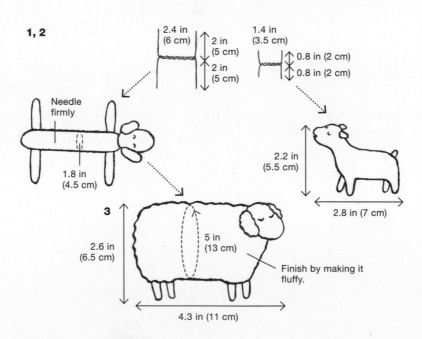

1, 2

2.4 in (6 cm) — 2 in (5 cm) / 2 in (5 cm)

1.4 in (3.5 cm) — 0.8 in (2 cm) / 0.8 in (2 cm)

Needle firmly

1.8 in (4.5 cm)

2.2 in (5.5 cm)

2.8 in (7 cm)

3

2.6 in (6.5 cm)

5 in (13 cm)

Finish by making it fluffy.

4.3 in (11 cm)

● Chocolate-Colored Bear

See pages 32–33 for photos.

. .

Materials

Raw wool
Body: Chocolate color, 3 oz (85 g)

Ear hole, nose base, palms, soles:
Mixed color (Light gray), a little

Sclera (white part of the eyes): White, a little

Pupil and nose: Black, a little

Steps

1 Make the head, body, limbs, and ears with raw wool and connect them together as shown in the diagram (see page 48).

2 Attach the ear holes, nose base, palms, and soles.

3 Attach the eyes and nose to finish.

It is effective to use a 3-needle or a 6-needle felting apparatus because of the large size of the work.

Make a round mound

Round cushion shape, 4 in (10 cm)

3.1 in (8 cm)

8.3 in (21 cm)

Cylinder shape, 6.3 in (16 cm)

Make this slightly flat

16 in (41 cm)

4 in (10 cm)

Cylinder shape, 5.5 in (14 cm)

Attach the round wool firmly

● Vickee and Co-B, Jack Russell Terriers

See pages 35–36 for photos.

. .

Materials

Raw wool
Body: Natural wool color, 0.4 oz (10 g) each

Spots: Camel color, a little; Nutmeg color, a little; Peach, a little

(Mix the three colors of the spots with your fingers.)

Ears: Chocolate color, a little

Nose: Black, a little

Leather belt: Red, 0.1 in (3 mm) wide; Blue, 4 in (10 cm)

Frisbee: Cheesecake color, a little

Glass eye, 2 pieces each: 0.2 in (4 mm) diameter

Braids, 2 pieces each: 9.8 in (25 cm)

Steps

1 Make the core of the body with 2 braids, wrap the raw wool around the body, then form the limbs and the body firmly (see page 50).

2 Make the head and attach it to the body, while needling the neck firmly.

3 Plant the hair for Vickee using the mixed colors.

4 Attach the spots, face, ears, tails, and collars for both dogs, and let Co-B hold a Frisbee to finish.

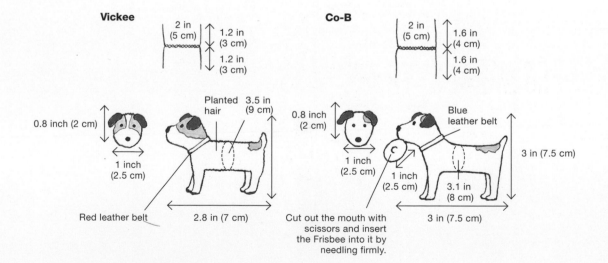

Vickee

2 in (5 cm) 1.2 in (3 cm) / 1.2 in (3 cm)

0.8 inch (2 cm)

1 inch (2.5 cm)

Planted hair 3.5 in (9 cm)

Red leather belt

2.8 in (7 cm)

Co-B

2 in (5 cm) 1.6 in (4 cm) / 1.6 in (4 cm)

0.8 inch (2 cm)

1 inch (2.5 cm)

Blue leather belt

1 inch (2.5 cm)

3.1 in (8 cm)

3 in (7.5 cm)

3 in (7.5 cm)

Cut out the mouth with scissors and insert the Frisbee into it by needling firmly.

● Charmy, the Cavalier

See pages 38 and 40 for photos.

Materials

Raw wool
Body: White, 0.4 oz (10 g)

Spots and ears: Red and brown, a little

Nose: Black, a little

Glass eye, 2 pieces: 0.2 in (4 mm)
diameter

Braid, 2 pieces: 9.8 in (25 cm)

Steps

1 Make the core of the body with 2 braids, wrap the raw wool around the body, then form the limbs and the body firmly (see page 50).

2 Make the head and attach it to the body, while needling the neck firmly.

3 Attach the spots, ears, eyes, and nose to the head.

4 Plant fluffy hair all around, attach the spots to the back, then attach a tail to finish.

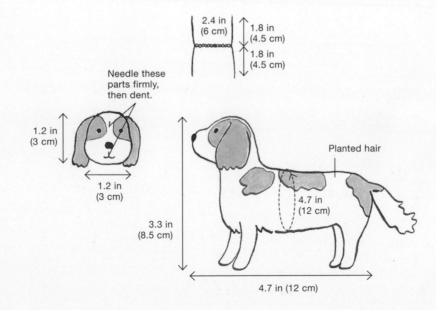

2.4 in (6 cm)
1.8 in (4.5 cm)
1.8 in (4.5 cm)

Needle these parts firmly, then dent.

1.2 in (3 cm)

1.2 in (3 cm)

Planted hair

3.3 in (8.5 cm)

4.7 in (12 cm)

4.7 in (12 cm)

● Beau, the Golden Retriever
See pages 39 and 41 for photos.

Materials

Raw wool
Body and limbs: Beige, 0.9 oz (25 g)

Chest: White, a little

Head, ears, and hair on the back:
Cookie color, a little

Nose: Black, a little

Glass eye, 2 pieces: 0.2 in (4 mm)
diameter

Steps

1 Make the head and attach it to the body, while needling the neck firmly.

2 Make the limbs and needle them on the body, while adjusting the shape.

3 Attach the ears, plant the hair on the chest and from the head to the back, then attach the tail.

4 Attach the eyes and nose to finish.

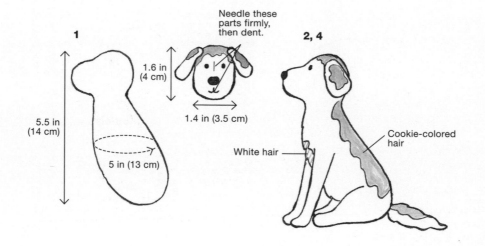

1

Needle these parts firmly, then dent.

1.6 in (4 cm)

1.4 in (3.5 cm)

5.5 in (14 cm)

5 in (13 cm)

2, 4

White hair

Cookie-colored hair

● Little Toddler Chick

See page 42 for photos.

● ● ● ● ● ● ● ● ● ● ● ● ● ● ● ● ● ● ●

Materials

Raw wool
Body and head: Chick color,
0.5 oz (15 g)

Wings: Chick color, a little

Bill: Pumpkin, a little

Eyes: Black, a little

Limbs: Tangerine, a little

Braid, 1 piece: 9.8 in (25 cm)

Steps

1 Make an egg-shaped body and lay it down (see page 48). Make a round head and attach it to the body.

2 Attach the wings, bill, and eyes.

3 Using the braid as a core, make the limbs and attach them to the body as shown in the diagram (see page 50).

4 Plant the hair over the entire body and make a fluffy feather toward the rear of the chick to finish.

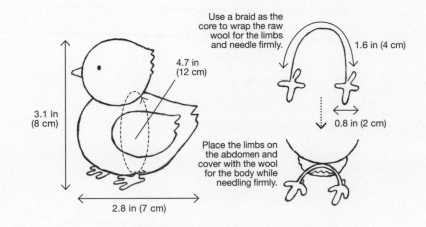

Use a braid as the core to wrap the raw wool for the limbs and needle firmly.

1.6 in (4 cm)

4.7 in (12 cm)

3.1 in (8 cm)

0.8 in (2 cm)

Place the limbs on the abdomen and cover with the wool for the body while needling firmly.

2.8 in (7 cm)

● Hana, the Sheltie
See page 43 for photos.

....................

Materials

Raw wool
Body: White, 0.5 oz (15 g)

Head: Red and brown, 0.2 oz (5 g)

Hair: Black, a little

Limbs' hair: Red and brown, a little

Braids, 2 pieces: 9.8 in (25 cm)

Glass eyes, 2 pieces: 0.2 in (4 mm)
diameter

Steps

1 Make the core of the body with 2 braids, wrap the raw wool around the body, then form the limbs and the body firmly (see page 50).

2 Make the head with red and brown wool, and attach it to the body, while needling the neck firmly. Then, attach the ears and eyes.

3 Plant the hair around the face, back, and chest, needling to produce a fluffy effect, then attach the tail.

4 Attach the red and brown hair on the limbs to finish.

2.4 in (6 cm)

1.8 in (4.5 cm)

1.8 in (4.5 cm)

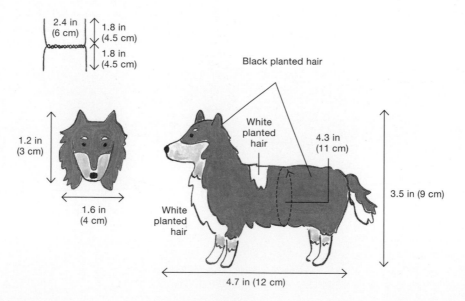

1.2 in (3 cm)

1.6 in (4 cm)

Black planted hair

White planted hair

4.3 in (11 cm)

White planted hair

3.5 in (9 cm)

4.7 in (12 cm)

● Toy Pony

See pages 44–45 for photos.

Materials

Raw wool
Body: Brown, 0.4 oz (10 g)

Hooves: Chocolate brown, a little

Mane and tail: Dark brown, a little

Braid, 2 pieces: about 11 in (27 cm)

Glass eyes, 2 pieces: 0.2 in (4 mm)
diameter

Red wooden wheel, 2 pairs

You can also make handmade
wooden wheels by making two
2 in × 0.4 in (5 cm × 1 cm) bars and
4 wheels of 1.2 in (3 cm) diameter.

Steps

This work is also explained with photos on page 50.

1 Make the core of the body with 2 braids, wrap the raw wool around the body, then form the limbs and the body firmly.

2 Attach the neck and the head, while needling the neck firmly.

3 Attach the hooves to the tips of the legs, then attach the ears and eyes to the head.

4 Plant the mane and attach the tail.

5 Glue the legs to the wheels to finish.

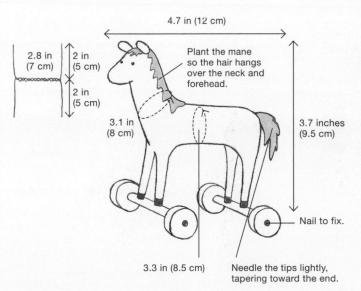

4.7 in (12 cm)

2.8 in (7 cm)

2 in (5 cm)

2 in (5 cm)

Plant the mane so the hair hangs over the neck and forehead.

3.1 in (8 cm)

3.7 inches (9.5 cm)

Nail to fix.

3.3 in (8.5 cm)

Needle the tips lightly, tapering toward the end.

Glossary

Here are some of the important terms and techniques used in this book. This list is useful when you are at a loss during the felting process or when you want to create your own methods as you gain expertise in needle and water felting.

Absorb
Intertwining the fabrics by stroking or rubbing with hands or fingers.

Braid
Steel wire with a fine thread that is intertwined with other materials. It is used as the core for a 3-D object to stabilize its shape.

Corriedale
One of the sheep breeds that produces fiber with an average thickness and hardness, which is easy to handle for a wide range of uses.

Cuticle
A very fine, thin layer on the raw wool's surface, cuticles resemble scales that overlap each other and align along the same direction. Wool is felted with cuticle scales that intertwine with each other.

Felt ball
A ball made from raw wool.

Felt (To)
This technique of shrinking raw wool is done by needling firmly or intertwining the fibers with heat, vibration, and friction. Wool can be felted into a sheet or a solid object.

Felting needle (see page 47)
This needle is used exclusively for felt work. Handheld felting apparatuses may hold multiple needles.

Fleece
Raw wool that is not processed after it is sheared and which has a thickness, length, color, and quality that differs by the sheep breed.

Hair planting (see page 50)
The technique of attaching raw wool on to a part that has already been felted by intertwining the edges of the bunch of raw wool.

Hand carder
This tool used for mixing different colors and types of raw wool resembles a brush. The wool is mixed by inserting and rubbing the raw wool between two carders. You can achieve different colors and properties delicately depending on the amount of raw wool that you mix and its quality. This tool is also useful for tearing or arranging raw wool.

Horizontal direction
The direction of the wool fiber's alignment as seen from the crafter's standpoint.

Making a bag (see page 54)
Felting the raw wool by wrapping the pattern and leaving the inner part hollow. It becomes a bag if you cut one side open like a mouth.

Making a sheet (see page 52)
Felting the raw wool into a flat sheet.

Merino
One of the sheep breeds that has soft and fine fibers suitable for making items that touch the skin directly, such as scarves.

Mixing color
Blending raw wool's different colors using a carder or other tools. It is possible to mix colors by tearing the wool with your fingers, especially if the wool comes in a small amount.

Needle felting (see page 46)
Felt work technique that uses a needle.

Needle firmly
To pierce the raw wool with a needle until the fabric attains its desired hardness. It is possible to produce various shapes depending on the positions pierced and the needling direction.

Needle (To)
To pierce the raw wool with a needle to attach it to a part that has already been felted. The wool becomes difficult to separate as the raw wool fibers are intertwined with each other.

Pom-poms (Making; see page 58)
Binding raw wool together and trimming the ends to create round shapes.

Raw wool
The fur of the sheep and other animals that is made into felt, wool, cloth, and other fabrics. It is generally classified into fleece or sliver depending on the material processing, such as whether the wool is scoured, combed, or otherwise.

Romney
Sheep breed with fleece that has thick and elastic fibers, which are suitable for items that require strength, such as a mat or indoor shoes.

Sliver
Fibers of sheared wool that are torn apart in a machine, the dirt or short fibers removed in order to obtain long and straight fibers.

Spin dry
Removing moisture in a spin dryer to finish the process of water felting.

Stripes
Pattern seen in a raw wool material that is made up of streaks of two different colors.

Taking out the pattern (see page 54)
In order to make a bag, the raw wool is felted on both sides of the pattern, and the mouth-like opening is cut open, then the pattern is "taken out" to make a bag.

Vertical direction
The direction of the wool fiber's alignment as seen from the crafter's standpoint.

Water felting (see page 46)
Felt work technique that uses hot water and liquid detergent.

Wrapping the pattern (see page 54)
This step is necessary to make a bag. Several layers of raw wool are laid on both sides of the pattern, and the ends are felted to fuse to each other at the edges.

Enjoying Handicrafts

Everybody knows that I am full of curiosity. Whenever I see something, I wonder, "What is this made of? How is it made?"

When I was a child, I loved school activities, such as field trips to factories and science workshops. How do we get pearls and honey? How do vegetables and fruits grow? How are sake and cheese made? These school events were so impressive that I cannot forget those first moments of discovery. I was thrilled to learn that a sweater takes only knitting needles and one string of wool to make. I wanted to try everything. There are many things that you can learn for the first time if you actually use your hands, and it is a great joy to experience the moment of completing something.

When I learned that cloth and dolls could easily be made from sheep's raw wool, I said to myself, "I will absolutely try it!" It's still a dream, but I would like to start raising sheep in the future. Raw wool is charming in many ways. Nonprocessed wool such as fleece has its own features in its color and texture. Two kinds of wool are never the same. Wool has weeds and seeds sometimes, and when you smell it, you can imagine a scene of a sheep eating grass in a distant meadow.

The simplicity and warmth of natural materials can make you happy when you touch them. Felt work is easy to try. I hope you spend many happy moments doing it.

—*Saori Yamazaki*

About the Author

Saori Yamazaki
Handicraft artist
Born in Tokyo; resident of Hayama, Kanagawa, Japan

Saori Yamazaki has spent a lot of her time doing handicraft since she was a little girl. Around 1999, a craft shop owner discovered her original works and began to sell them. Since then, more stores have stocked her works, and starting in 2001 she concentrated mainly on handmade felt works. Her work has appeared in magazines and other media, and is increasingly popular. Currently, she holds lectures and exhibitions, and she exhibits and sells her works on her Web site, www.atelier-charmys.com. Some of her most popular items are custom-tailored felt dogs. Her companion dogs, Charmy and Beau, who appear in this book, are her important partners in her life.